Photography: Where Science Creates Art

Laura Lawn

Contents

Introduction

"You don't take a photograph, you make it." ~Ansel Adams

Photography is an art form, an art through which you can express yourself to the world. You can use the lens to reveal a world you may not have seen otherwise. You can show others your perception of the world and its inhabitants. Photography is an exciting hobby to share with friends, a reason to go exploring our natural and man-made world, an excuse to go on fabulous trips to beautiful places, and a way of remembering the good times with good friends.

Cameras pervade our everyday life. We have cameras in our purses, in our pockets, in public places, even on our phones so we can shoot a photo instantly to share with friends in other places in the world. Photography and visual imaging are rapidly becoming a prevalent form of communication.

Photography is all about the choices that you make and the results of those choices. Many a student has commented, "I didn't know that there was this much thinking involved" in photography. Initially, the multitude of settings, the acronyms, and the decisions to make may intimidate beginning students, so they tend to leave as many settings on automatic as they can. But not making conscious choices leaves those choices to the camera and the camera limits its choices to "the average," what generally works. Taking the time to familiarize yourself with your camera will make you more confident in your ability to make intelligent choices about the images you capture.

Photography is a personal art form. The camera is simply a tool of that art. Just as you would not let your brushes paint a picture for you or a pencil write a novel for you, you shouldn't let your camera take your picture for you. It will if you don't monitor it. You must remember the importance of making conscious decisions when using your camera. You are in control of the final photograph, not your camera!

When I was learning photography, I was frustrated at the lack of a text that showed the entire process of creating an image from start to finish. I found books on composition or on color or on exposure, but no one single book that filled in all the gaps left by studying on my own with magazine articles and surfing the Internet. Photography: Where Science Creates Art will explain that fundamental knowledge from camera operation to the science of light and color to the visual artistry of photography. Since the underlying camera operation and photographic knowledge is the same regardless of the specialty that you choose to study, this text will discuss a broad range photography, from macros to landscapes to portraits and more. Furthermore, this book is designed to be both a beginner's guide for those students who have little to no experience with the camera as well as a more advanced reference for intermediate to advanced students. Each chapter, while building on the previous chapter's information, can be read individually. While I recommend that you read the entire book from front to back several times (of course, marking your favorites wisdom-filling passages...) it is organized to allow you to begin with any chapter, read in any order.

Photography: Where Science Creates Art is about the choices involved in photography. First, I discuss the equipment itself. Chapters 1, 2, and 3 discuss the intricacies of the main tools that photographers use: the camera and lenses. Chapter 1: *Introduction to the Digital Camera* introduces the features common to the digital camera and compares the camera to human vision and perception. Here we discuss the choices involved in picking out the camera right for you.

Chapter 2: *The Digital Camera - Settings and Features* discusses lenses and the main features of the digital camera. These features are commonly found on all cameras, regardless of the price tag. However, you should make sure you have your camera's manual (you can download it from the camera maker's website if you no longer have your copy) to reference your individual camera and its options.

Chapter 3: *Understanding Exposure Control* delves into exposure for a deeper understanding of the camera. Here I discuss the choices involved in rendering motion, maximizing or minimizing depth of field, low light photography, and manually controlling exposure.

As light is the basis for every image you will ever capture, a good understanding of what light is and how it works is essential for true photographic skill. In Chapter 4: *Writing with Light* we move on to study the physics of light, how light interacts with the subject, how to read the light, and the choices about using natural light and how to modify light when needed.

Chapter 5: *Color Theory and Usage* examines the psychology of color, color theories, color interactions, and how to use color to touch another's emotions. Both the color of the light and the color of the subject have high impact on the mood of the finished piece, so I discuss them both.

Then I move on to composition and visual design in Chapter 6: *Composition and Visual Design* where I look at defining a subject, then placing and emphasizing that subject through arrangement of the various elements within the frame, and creating the 3rd dimension with perspective.

Chapters 1-6 cover the fundamentals of photography. Chapter 7: *Creativity* helps you develop your style, your creative eye, not only through a perceptional change, but also with a variety of equipment techniques both within the camera and in post-processing.

Chapter 8: *Putting Theory Into Practice* puts the theory throughout the text into practice by walking you through several photo sessions and the thought processes involved in the creation of the images. First, I show you a people-oriented session, a trip to Disneyland and all the experience that accompanies it. People are unpredictable and events tend to take on a life of their own. Working an event becomes an exercise in quickly accessing your skills and responding to the fleeting moments. Next, a more sedate nature session, built more around carefully creating images instead of quickly responding to the changing situation.

Lastly, Chapter 9: *Self Analysis* discusses self-analysis and objectively viewing your own art to help you continually improve. Here I go back and analyze all our choices to see what could have been improved upon.

This text should be used to help you develop your own individual artistic style. While I may mention what has traditionally been done, or what I prefer to do, this is only one choice. The final choice for your artistry is yours. With that said, let's begin our journey.

1 Introduction to the Digital Camera

"Mastering the technical details that make up the craft of photography is only the beginning. To make photographs that communicate your ideas or feelings, you will also have to learn the differences between human visual perception and the way photographs represent reality." ~Bruce Warren

Whether you are thinking of getting a new camera or learning to use your own better, the camera is an intricate and wonderful tool! You can see the world through a new perspective, literally seeing things you simply cannot see with your eyes alone, things you may never have noticed just walking by, and you can even show others what you see. Photography is also a highly personal skill, one that requires constant thought to continually create new and unique images.

To some, the camera represents a broad new frontier that they are eager to explore while others see it as an intimidating box with a foreign symbolic language inscribed on it. Either way, the camera, and more specifically the ability to capture a moment in time, holds great fascination for us.

Cameras surround us daily. We have cameras in our purses, on the computers, in our pockets, even on our phones. The camera is becoming a commonplace tool that surprisingly few people truly understand. The camera can be easy to use, but to use it well, to use it effectively, you have to understand how it works

and, most importantly, how the camera differs from our own human vision. The biggest complaint I hear from students is that the image "doesn't capture what I saw." The camera functions differently from the human perceptual and visual systems and understanding that difference will help you along the path to great photography.

THE CAMERA IS NOT THE EYEBALL

The basics of creating a photograph can be easy if you understand your equipment. Light travels from a light source (natural or artificial) to the subject of your photo and bounces off that subject to the camera. The light then passes through the lens, which gathers and focuses the light. The light goes through a small hole called the *aperture* and onto the film strip in a film camera or the *CCD or CMOS sensor* in a digital camera. The film or CCD reacts to that light (called *exposure*) and the resulting image can be viewed either by processing the film (in film cameras) or by downloading the digital information to a computer (digital cameras. Note: digital cameras have a built-in computer and an LCD for immediate viewing of your photograph – one of the perks of a digital camera over film cameras.)

The camera itself has often been compared to the human eye. It is true that there are some similarities, which may make the camera's operation easier to understand, but there are also many differences, ones that can confuse you if you don't remember how the camera differs from the eye. Light takes the same path regardless of whether you are collecting it with your eye or the camera, so we will leave the discussion of light until Chapter 4: *Writing with Light*. Let's start with a basic discussion of how the eye works.

The human eye has many parts that act similarly to the camera. Our pupil has the same function as the camera's aperture (opening and closing to adjust the amount of light entering the eye/camera at one time). We have a lens, just like the camera has a lens. We even have an eyelid, which is similar to the camera's shutter, opening and closing to control light entering the eye/camera. Light enters the eye through the pupil and travels through the lens, which focuses the light and sends it directly to the retina, which is similar to the sensor in the digital camera (or the film strip in a film camera). The retina collects the sensory information and sends it down the optic nerve to the brain for processing.

However, when we explore the eye in detail, the similarities end and the differences become obvious. Our pupil is constantly being monitored and adjusted by the brain; the aperture of the camera has no brain to trigger its changes, so you as the photographer must be that brain; you must manually change the aperture to adjust the amount of light entering the camera. As you look around a scene in front of you, your pupil automatically responds by opening and closing minutely according to how much light in is the part of the scene you are looking directly at. The camera cannot adjust as it looks around the scene; it can only have one aperture size for any given image. This means that we can look at a scene and not "see" as drastic a difference in light levels (our eyes are constantly adjusting for the changing light) as the camera will "see" (which has no adjustment for the light).

On this same note, the human eye can pick up detail in a wider range of light levels, called *tonal contrast*, than the camera can. Cameras have

between 4 and 10 "stops" of light (a measurement we use in photography) that it can detect without losing detail in the highlights or shadows, depending on what type of camera (and what type of film, only B&W film can do 10 stops) you are using. The human eye can pick up between 14 and 16 stops of light (and even up to 24 if you count the adjustments of the pupils as the eyes scan the scene.). So, not only can the pupil automatically change size to adjust for the light levels, we also can detect and process more tonal contrast than the camera can without losing detail in the highlights or shadows. You may see a scene in perfect detail but the camera shows that same scene with overblown highlights and deep, dark shadows.

On the other hand, sometimes the camera can do more than the eye can. The lens of the eye does not change, while you can change the lens' focal length on the camera allowing the camera to see more, or at least differently, than the eye does. You can explore a scene in more detail and with wider variety with the camera's lenses than with your own eye lens. You can only see one angle and distance of view with your eyes, but with camera lenses, you can change the angle of your view from a wide angle to a narrow angle; you can "zoom in" and "zoom out," which you certainly can't do with your eyes. There are also many different types of special effect lenses that you can attach to your camera, which is not possible with the human eye (although it might be interesting if we could). For example, there is a lens called a *fisheye lens* that can "see" 180° in clear focus. Even with our peripheral vision, our forward facing eyes cannot see this range of vision.

However, since we have two eyes, one on each side of our face, we have **binocular vision** which allows us to have two slightly different perspectives of the scene in front of us. Have you ever lain on one side and closed the bottom eye, then switched to the top eye? The world seems to jump when you switch eyes. This exercise is an example of the two different perspectives of the same scene. The brain combines these two different images into a single sensory image and gives us the perception of depth, of a third dimension, 3-D. The camera has only one lens to collect information with, which means the camera lacks the ability to provide depth. Any sense of depth is your responsibility to add in. We will cover this concept and how to correct for it more in Chapter 7: *Composition*.

Even the function of the eyelid is not exactly the same as the shutter of the camera. The human eyelid stays open until it needs to close to re-moisten the eyeball. The shutter of the camera stays closed until it needs to open to allow light to reach the sensor. Therefore, only a brief moment in time is collected in the camera, whereas the human eye is continually collecting information and processes it in its entirety.

On the whole, it is best to think of the camera as unrelated to the human eye because continuing to make the association will limit your abilities and lead you to make creative mistakes with the camera. You must understand how the camera works and then adjust your perception of the scene in front of you to match what the camera will see. If you continue to expect the camera to record information as your eye does, you will be disappointed in your imagery. Recognize how the camera differs from the human eye and adjust the camera to make it do what you want it to.

THE PSYCHOLOGY: VISUAL PERCEPTION

Visual perception is a complex field and worth more time than I can devote here, so please realize that this is a simplified discussion of visual perception. Knowing, in detail, how the viewer will perceive the image helps every photographer, but this is a photography text, not a cognitive psychology text, so this book will stick to the basics.

Visual perception is a response to a visual stimulus (light), a sensation that activates the light receptors of the eye. Light travels through the pupil, lens, aqueous humor and vitreous humor (jelly-like substances that help focus the light and help the eye maintain its shape), to strike the receptors on the retina. Those receptors transfer information down the optic nerve to the brain. This begins the process of perception. *Perception* is the attempt to understand and make sense of the stimuli received by the brain. That means that the brain *interprets all incoming visual stimuli.*

Did you know that shared reality does not exist? I know, you look around and see things all around you; you can touch and feel things, so it must be real, right? Not quite. Every sensory stimuli (touch, smell, taste, hearing, and sight) is perceived and interpreted by the brain. Every experience we have, every reaction we go through, and every situation we find ourselves in, is biased by our past experiences, our emotional states, and our physical comfort levels. Think about it, have you ever taken offense at someone even though he didn't mean to be offensive? Have you ever been grumpy when you felt sick? Does the smell of cookies or apple pie baking make a house feel more appealing? Perhaps the smell of fish tacos makes you ill because they caused you to get food poisoning. The brain is always attempting to fit new, incoming information into the pre-existing set of information, so you are always making associations about your daily experiences.

I tell my students that even though each one of them is sitting in the same room, with the same environment, listening to the same things, each student will come away remembering different things about the class. Some may walk away with a new found fascination for photography; others may decide that photography requires too much thinking for them. Some may remember my fabulous sense of humor while others may be more concerned with the temperature in the room and the hardness of the seat. Perception varies from person to person so much that some things, such as color, are sometimes considered to be more a perceptual sensation than a physical property of the object. The physical objects in the environment are only part of our daily experience; the other part is wholly personal, wholly perceptive. It is that daily experience that determines who you are. Reality does not exist; it is your perceptions of the world and of yourself that determine your day-to-day reality.

This lack of a shared reality makes finding your "style" in photography easy. No one else has your experiences, no one else has your perceptions, and no one else has your vision. Photographers bring their own personal reality to their photography. You bring your past experiences, your sense of humor, your unique "eye" for imagery which, in turn, brings something of yourself into the final image. The best photographs are made of the subject speaking through the photographer to the viewer. You, the photographer, must be in there somewhere or else the image is nothing more than a pretty snapshot.

The Technology: How The Camera Works

Okay, that was enough psychology; time to get back to "reality" (hee hee) and back to the camera. Let's review how the camera works in a bit more depth as there are several steps to the process. Light travels from a light source (natural or artificial) to the subject of your photo and bounces off that subject to the camera. The light then passes through the lens, which gathers and focuses the light. Then the light goes through a small hole, called the **aperture**, through the **shutter** (a door that has briefly opened to allow the light through), and onto the **sensor** of the digital camera. The sensor reacts to that light (creating **exposure**) and the resulting image is saved to your memory card.

You have choices to make all along this pathway, each of which will affect the finished image. As a beginner, you may choose to leave certain settings in Automatic until you are comfortable enough with other settings, but remember that eventually, you should be making all the choices, not letting the camera make them for you. Different cameras allow for different choices to be made.

Observe: Yourself and Your Needs

The first step in photography is to choose a camera to use. Cameras are tools, nothing more, each with its own advantages and disadvantages. You must choose the one that best fits your needs and desires. What kind of camera do you have or do you want to buy? What do you need or want the camera for? Convenience? Creativity? Travel ease? Professional use? Do you need a low weight camera? Do you have strong wrists or weak wrists? What does your budget look like? These needs will dictate what kind of camera to use, which will further dictate what you can do with the camera.

The Choice: Selecting the Tool to Use

Point 'n Shoot (PNS) cameras are convenient, portable, and affordable these days. They come in small, pocket-sized frames with multiple user-friendly features designed to assist the beginner who knows little to nothing about photography. PNS cameras are great for simply snapping a picture without having to think about all the confusing settings and take the time to plan out your image.

These features may sound like a bonus, but the downside to these models is that they often have a reduced capacity for camera control so even when you do want to take control, you cannot. If you have any adjustable settings, they are usually limited in range compared to the more controllable D-SLRs (see below). Many less expensive models give you literally no control over the finished image (other than framing the image, of course). Many students also complain about the shutter

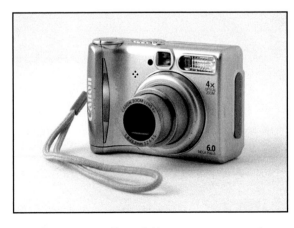

A **PNS camera** is readily available to consumers, convenient, inexpensive, and easy to use.

lag that comes with PNS cameras. Most PNS cameras have a lag time between when you press the shutter button and when the camera actually takes the image, which causes many a missed photographic moment. If ease of use, lack of a need to think and plan, and higher convenience is your goal, the PNS might be for you. If your goal is having full creative control, the PNS is probably not for you.

Hybrid cameras are a nice combination of the cost effectiveness of the PNS and the camera control of the D-SLR, hence the name. Hybrids usually have a larger range of creative control than the D-SLR but at the price of being a bit larger and bulkier. They can often still fit in purses or small bags, but rarely into pockets.

The one major downside to the hybrid camera is the lack of interchangeable lenses. D-SLR cameras have a full line of lenses that can be used, changing your viewpoint dramatically. Hybrid cameras have an attached lens so you do not have the ability to go beyond that single lens. On the other hand, though, that can drastically reduce your later equipment costs, as lenses are the biggest expenses that photographers spend money on. If you can't change the lens, you will not be tempted to buy more of them.

A **D-SLR camera** allows the photographer to adjust all the internal camera settings and to change lenses for more creative variation.

Digital Single Lens Reflex (D-SLR) cameras offer the widest range of creative control over our finished photographic image. D-SLRs have fully adjustable settings (whereas the PNS have limited ability for adjustments), although some models have a slightly wider range of each setting (for example, some models offer a setting called ISO that goes up to 1600 while others offer an ISO that goes to 6400 or higher). D-SLRs also have interchangeable lenses which is one of the best aspects of photography. The lens you place on the camera dictates how you see and record the world; are you looking at details 300 feet away, are you seeing 180° around you, or are you counting the hairs on a bumblebee's back? The ability to change the lens, the "eye" of the camera is invaluable.

You can make many of the photographic choices I discuss in this book regardless of the type of camera you have. While I recommend that anyone who is truly interested in photography eventually get a D-SLR, it is more important to know how to use your current camera so you can make the best use of what you already have. Remember, you can take good images with any camera; the camera is just the tool that you, the photographer, use.

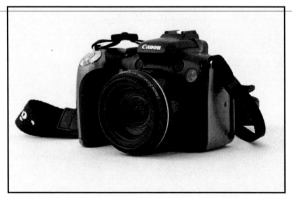

Hybrid cameras have a good combination of the PNS's convenience and low cost with the internal camera controls of the D-SLR.

Technical Tip:
When depressing the shutter button, rest your finger on the outer edge of the shutter button and roll your finger backwards to prevent unwanted vibrations in the camera.

2 The Digital Camera - Settings and Features

"It matters little how much equipment we use; it matters much that we be masters of all we do use." ~Sam Abell

Now that you have chosen which camera best fits your needs, it is time to start learning how to use it. Remember, the camera is nothing more than a tool you use to create your vision. The main thing is to enjoy your time with it, enjoy the process of photography. Do not get overwhelmed with the number of buttons or the variety of settings; tackle one setting at a time until you are comfortable with everything. Some settings rarely need to be changed while others should be adjusted with every image. While I will discuss some of the most common and useful settings here, I will leave it up to you, the reader, to check your camera's manual to see which settings your specific camera has and exactly how to access and use that setting (for example, some cameras have exposure controls on a dial on the camera body while others require you push a menu button to access them). Eventually, you will have total control of the camera and will be comfortable adjusting settings quickly.

THE TECHNOLOGY: ASSEMBLING THE TOOL

Lenses & Understanding Focal Length

Changing **lenses** (the eye of the camera – the glass that lets light in) allows you to photograph and share a point of view that wouldn't be normally seen by the human eye. When distinguishing lenses from each other, we talk about the focal length of the lens, which ranges from 10mm (ultra wide angle) to 800mm (ultra telephoto). The **focal length** of the lens refers to the length, in millimeters, from the focal point within the lens to the sensor of the camera (or film in the old days).

Different lenses change what and how we see through the lens. Various lenses allow us to change both the angle of view and the distance of view to our subject. A **wide-angle lens** allows us to show a wide angle (versus a narrow angle) of vision. Remember math class, studying angles where a 90° angle is a right angle, a 180° angle is a straight line, and a 360° angle is a full circle? Using this same concept of angles, the wide-angle lens shows an angle of 60° or more while telephoto lenses show a more narrow angle of view. Some **ultra wide angle lenses** can show up to 180°, a feat the human eye cannot achieve.

Lenses can range from 10mm to 800mm while normal human vision can be approximated by using a focal length of about 50mm, so photographers are able to photograph in wider and narrower angles than we can see. This increases your level of creativity and allows you to see the world in a new way, one that you would not be able to see without the use of the camera's lens.

> **Technical Tip:**
> Auto Focus requires tonal contrast to be able to determine the edges of the subject so in low contrast or low light situations, you may not be able to use auto focus. Be sure to practice with manual focus so you do not have to rely on the auto focus.

Wide-Angle Lens
Wide Angle of View

Telephoto Lens
Narrow Angle of Veiw

USING LENSES

WIDE ANGLE LENSES

Wide-angle lenses are denoted with a focal length of less than 35mm, which gives you an angle of view of 60° or more. There are also **ultra-wide angle lenses** that can range from 10mm to 22mm. Wide-angle lenses can show a great deal of distortion. Wide-angle lenses elongate

Focal Length examples

Focal Length	Subject	Lens Type
10-20mm	Complete arc of rainbow	Ultra Wide Angle
24-75mm	Landscapes & intimate scenes	Wide Angle to "normal"
105mm Macro	Plants & insects	Close-up Short telephoto
100-300mm	Whales from a boat	Telephoto
300-600mm	Timid wildlife	Ultra Telephoto
200mm Macro	Small Animal Close-ups	Close-up Telephoto

Observe: Focal Lengths

Using a focal length of **18mm,** this image has an exaggerated foreground and elongated perspective, showing depth in the image of Oregon's Capitol Building in Salem.

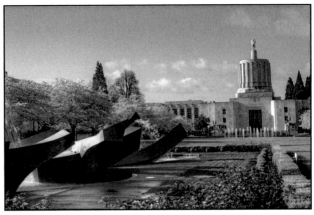

At **35mm,** the focus is more on Capitol Building.

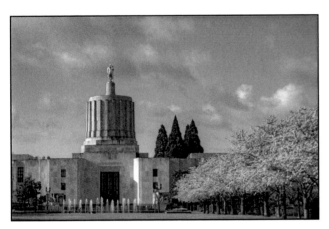

A **55mm** lens removes the foreground sculpture, enlarging the building within the frame.

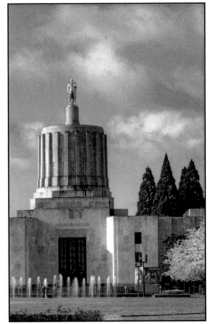

A **80mm** lens brings the focus to the Tower, leaving the rest of the building as a base for the Tower to rest on.

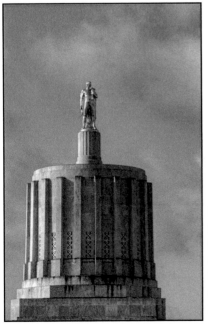

Using a **140mm** lens, you can focus on the Tower and the Oregon Pioneer who sits atop the Capitol Building.

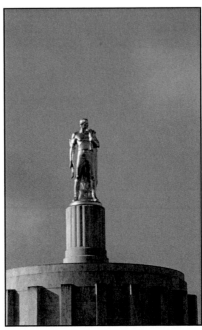

A **250mm** telephoto lens allows us to see detail within the statue itself.

the various elements in the composition so there seems to be more distance between the foreground and background than you may see with your eye. This effect is called *elongated or exaggerated perspective*. The effect is more noticeable as you move the camera closer to a foreground object. There is more distortion as the focal length decreases and the angle of view widens. Many ultra wide-angle lenses have the ability to focus from less than one foot away from your subject, allowing you to use that exaggerated perspective to its fullest creative ability. This distortion can help you retain perspective, the visual illusion of depth, which helps retain the third dimension. It can also make for silly portrait effects as it stretches the human body as well.

A second effect of using the wide-angle lens is that it will make *converging parallel lines* when tilted up or down. The wider the angle of the lens, the more noticeable the effect will be. As we look off into the distance with our eyes, parallel lines tend to converge naturally, showing us vanishing points where those lines disappear into the horizon. This lens effect can change your perspective and

Using a wide angle lens tilted upward distorts the image, creating a **barrel effect** (the bowing of the trees towards the edge of the image).

your composition, helping you to show depth in your scene. To counteract this effect and retain your parallels, make sure the camera stays level to both the ground and the subject.

Another distortion of the wide angle lens is called the *barrel effect*, in which straight lines seem to bow, especially at the edges of the frame. You can choose to correct for this distortion by placing your subject closer to center of the frame or you can use it purposely for creative effect. Again, the distortion becomes more obvious as the angle of view gets wider and the focal length decreases. Specialty *fisheye lenses* give you a 180° perspective that shows a curvilinear perspective, rendering straight lines as curves, an exaggerated barrel effect.

Another specific effect of the wide-angle is a more pronounced depth of field when compared to a telephoto lens, even at the same aperture setting (the hole that light goes through

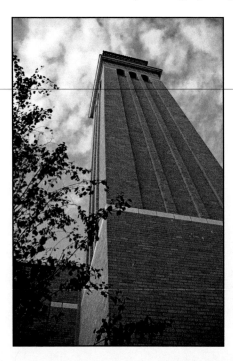

A wide angle lens, when tilted upward, creates **converging vertical lines**, shown here on the bell tower for the Mt. Angel Abbey in Oregon.

Technical Tip:
When using telephoto lenses, use a shutter speed that is the reciprocal of the focal length of the lens (so a 200mm lens would need a 1/200 shutter speed).

which controls your depth of field). Wide-angle lenses show large portions of landscapes and this increased depth of field helps to ensure a clear image throughout the entire landscape. We will discuss depth of field more later in Chapter 3: *Understanding Exposure Control*.

TELEPHOTO

Lenses that have a focal length of 80mm or more are usually considered **telephoto lenses** (from about 80-200mm are considered short to medium telephoto, 200-300mms are telephoto, and 400mm+ are ultra telephoto) and they produce a look that is very different than that of wide angle lenses. Telephoto lenses have a shallower depth of field (DOF) naturally than the wide angle lenses do, and the longer the lens (the larger the focal length or the more telephoto the lens), the shallower the DOF. Therefore, a telephoto lens at an aperture of f/5.6 will have a shallower depth of field than a wide angle lens set at f/5.6 (more on aperture sizes in Chapter 3: *Understanding Exposure Control*).

Telephoto lenses compress the elements in the composition so the background seems closer and looms large over the foreground, an effect called **compressed perspective**. This compressed perspective combined with the shallower DOF is especially flattering for portraits.

On the flip side, though, telephoto lenses increase the blur of motion even at the same shutter speed as the wide angle (the telephoto lens is heavier and needs a faster shutter speed to stop motion). This means you can hand hold wide angle lenses at a longer shutter speeds than you can a telephoto.

18mm lens

Notice the difference between the perceived distance between the background and foreground when looking through two different focal lengths. This change in **perspective** can drastically alter how you render your subject.

55mm lens

ZOOM VS. FIXED FOCAL LENGTH LENSES

When it comes to lenses, we also differentiate between zoom lenses and fixed focal length lenses. Both are good lenses to have in various situations. **Zoom lenses** are lenses that can "zoom" through multiple focal lengths while **fixed focal length lenses (or prime lenses)** are lenses that have one and only one focal length. Zoom lenses are convenient, especially for fast moving subjects, because you can capture a variety of different distances and angles of view without having to move your body much. This helps, for example, when you are at the back of the church and want to get a close up of the exchanging of rings in a wedding (can you imagine running right up in front of the ceremony to get a close up?) or when you are working with a young child or pet who moves quickly and randomly and you can't keep up with all that energy.

In exchange for that convenience, though, the zoom lens lacks the extra clarity and quality that the fixed focal length lens has. Zoom lenses are able to zoom because they have multiple elements, pieces of glass, that literally move around within the lens. With each new piece of glass you get the chance for glare or image degradation. Fixed focal length lenses have a single focal length and fewer internal pieces which means a slightly higher quality of finished image. I find that when I am working with the majority of my subjects, the zoom's convenience outweighs the possible quality loss, but when focus is my primary concern, as with macro photography, I switch to the fixed focal length lens.

THE CHOICE: WHICH LENS?

Which lens do you want to use? Your lens choice is based around what you want to use the lens to capture. What is the subject? Is your subject close to you or far away? Wide-angle lenses give you a wider angle of view, a deeper DOF, and an elongated perspective (which can lead to distortion if you are not careful). These lenses are great for landscapes and urban life type images. Telephoto lenses give you a narrower angle of view, a shallower DOF, and a compressed perspective. These lenses are well suited for portraiture or for viewing far away subjects close up.

Is clarity of utmost importance? Then you may want to look into prime lenses. Need the convenience of the zoom lens? What range should you have? Many cameras come with a wide angle "kit lens" that serves as a good starting point. If possible, I recommend a full range from 10-300 mm (or as close to that range as you and your budget can come).

There are even specialty lenses that can enhance your work. **Fisheye lenses** show a curvilinear perspective, rendering straight lines as curved lines. It makes the world look like you are in a fishbowl looking out. **Macro lenses** are designed to focus closer to the subject than normal lenses can and to magnify the subject.

THE TECHNOLOGY – FILE FORMAT / IMAGE SIZE / QUALITY

One of the first things you should do with your new camera is to determine what type of files you want to record. All digital cameras default capture as a JPG file (the most common printable digital image file), but many have other formats that can be more useful to the overall photographic process.

DIGITAL IMAGE FILES & PROCESSING

A *Joint Photographic Expert Group* file (*JPG*) is the most used image format. Many beginning photographers use the JPG format to record their images because of its smaller file size, which allows you to get a larger number of images on your memory card. The camera also processes the digital file for you, allowing for ease of printing and sharing with no timely processing needed; just take the image and print it. The JPG is all about fast and convenient.

Those bonuses come with a price, though. With the file compression, you will lose much of your originally recorded data. When you photograph in JPG format, the camera takes care of the post-capture processing for you, setting the exposure, the white balance, etc. The camera assumes that you took the image perfectly and do not want to process it yourself later. It assumes that you simply want to take the memory card to the lab and print out your files. So, the camera processes the file for you and then compresses it to a smaller size, up to 1/16th the original size. This, unfortunately, means that you have given up all the control on the processing to a machine and then thrown away up to 15/16ths of your original data. This compression makes it much harder, if not impossible, to go back and change the camera's processing should you decide that you did not like what the camera did. Most cameras allow you to dictate how much compression takes place, so check your manual and use the smallest amount of compression, saving the most digital information, and giving you the largest files you can. Using minimal compression will give you better files to work with when it comes time to print your work.

With a *RAW file*, the camera records and saves all the data that is captured and this data is left unprocessed by the camera; there is no color correction, tone curve, sharpening, noise reduction, etc. All that processing is left to you, the artist, in the digital darkroom. The upside of this type of file is that you retain all the necessary information to be able to process the image yourself, allowing you to exert your creative mind over not only the capture of the image, but also its processing, just as film photographers used to control the print making process in the darkroom. The downside is that you absolutely must process the image before you can view it, share, or print it. If you take a memory card down to the lab with RAW files on it, they will tell you your card is empty. You must process the RAW files before using them which means you must have image processing software, a computer capable of running it, and time to sit and process.

Nowadays, cameras that allow you to photograph in RAW provide you with software that will open RAW files and do minor processing. Most of these programs are not worth the effort. The industry standard is the Adobe line of software, and there are several that are worth mentioning. Adobe's *Photoshop* is a large and expensive program that allows you to have the absolute widest variety of processing options. You can simply adjust your images or you can create multi-layered composites with many special effects. Photoshop is a wonderful program, so if you are interested in doing your own post-

> Some PNS cameras do not have a RAW file but allow you to capture a TIFF file. The TIFF (Tag Image File Format) uses compression similar to the JPG, giving you more space on the memory card than with RAWs, but without the "lossy" compression. TIFF files use a "loss-less" compression to reduce file size while retaining the ability to process the file later. The TIFF must still be processed before viewing, sharing, or printing.

processing, you can visit your local bookstore for a good book on Photoshop. However, this program can be overwhelming and is usually more than the everyday users need for their work; it is designed for professionals in the industry.

Adobe's **Photoshop Elements** is another software program that works well to process our images. Elements is a piece, or an "element," of the whole Photoshop program. Photoshop itself is designed for professional photographers and often carries far more information than the common user needs or even wants, so Adobe released Elements to meet the demand of the common user. Elements allows you to make simple adjustments or create elaborate multi-layered documents as well as giving you the opportunity to organize your images, create slide shows, and share your images via the web. This program is very useful for the nonprofessional photographer who wants a processing program that is not as expensive or complex as the full version of Photoshop.

A third, and my favorite, Adobe software program is **Lightroom**. This program is a bit newer, but it is specifically for managing adjustments on many different images at one time. Let's say you go out and photograph an entire session with your white balance set to tungsten when you are photographing in the sun. With Lightroom, you can adjust just one image to the correct color and then copy or sync the settings of all the other images with the one corrected one, saving you time and work. The downside of Lightroom, compared to the other programs, is it does not have the ability to use layers. Lightroom is perfect for those photographers who only want to adjust their images, not create multi-layered documents.

OBSERVE: YOU AND YOUR NEEDS

What are your needs? Do you have the time, the interest, and the software to process RAW files or does the instant accessibility and small file size of the JPGs appeal to you more?

THE CHOICE: RAW OR JPG

JPG files are great for convenience of printing, sharing, and storing. JPG files are smaller and are compressed during which they lose data, meaning they take up less memory card space but you have a smaller file to print with later, meaning smaller prints. RAW files are much larger so you cannot store as many of them at one time but you retain the full editing capability of the image and can usually print much larger prints from the files.

What file format best fits your needs? Do you need immediate access to prints and file sharing? Do you have a computer? Do you have image processing software? Do you want to post-process?

THE TECHNOLOGY - LIGHT METERING / READING THE LIGHT

Light meters are instruments that can read or measure the amount of light in the scene. Several types of light meters are available to the photographer: incidental, reflected, and spot. **Incidental light meters** measure the ambient light intensity directly around and in front of the subject, called the incident light. These are hand held meters so you can (and have to) put them in the same light as the subject. There is a single intensity of ambient light at any given time and location, so this measurement shouldn't change unless the environment changes.

Reflected light meters measure the intensity of light that is bouncing off the subject, the reflected light. These meters can be handheld or built in to the camera. However, the intensity of reflected light changes depending on the color of the subject. A light subject (a winter hare in snow) will reflect more light than a dark subject (a black panther in a shadowed jungle). An incidental light meter will measure the same for the light and dark subjects because it is measuring the light hitting the subject. Reflected light meters measure the light coming off the subject, so that reading varies more based on the subject you are photographing.

Spot meters read the reflected light coming off of a specific spot in the image. Spot meters are much more accurate as they can measure numerous light intensities within the same scene instead of averaging the entire scene into one reading.

The Choice – Metering Modes

Your camera has an internal light meter that allows it to read the levels of light in the scene in front of you and determine the "correct exposure" for your image (see *The Technology: 18 percent Grey*"). Internal camera meters can often times switch between different metering modes, ways of metering the scene in front of you, although these modes all are reflected light metering modes. Many cameras have the option between Overall or Evaluative metering, Center (some differentiate between center weighted and center spot), or Spot mode. **Overall or Evaluative metering** means the camera divides the image into multiple sections, meters each section, then creates an average, overall reading for the entire scene.

Center weighted focuses the metering over the center of the image, where many new photographers commonly place their subjects. However, when we get to Chapter 6: *Composition* we will find that the center is often the least visually appealing place to put the subject.

Spot metering meters solely from the center of the frame. The rest of the composition becomes irrelevant in figuring the exposure; only the one spot matters in the metering. This specificity allows you to choose a specific spot within the composition, zoom in and meter off that single spot, then recompose the image, using the spot meter reading.

Different situations benefit best from different metering modes. Often landscapes and broad scenes can best benefit from the Overall or Evaluative metering, which will account for the whole scene in calculating exposure. Spot metering works well for portraiture where you care more about exposure on the face and less about the rest of the scene. Try each metering mode that your camera has and see which one works best for you and your work.

The Technology: ISO

The term ISO (which stands for International Standards of Operation) refers to a time when we used film instead of digital sensors to collect our images. Film was composed of layers of emulsion, a chemical that required light energy to activate. This emulsion ranged from needing a lot of light energy (low ISO settings such as 50 or 64) to needing very little light energy (higher ISO settings such as 800). While we no longer use the

These images were all taken during **low light**. In the left image, the shutter was allowed to stay open for 1.6 seconds to let in enough light to get good exposure and keep the ISO low (notice how there is no noise in that image).

The right image was taken with an ISO of 12800 to allow the shutter speed to come down to hand-held speed: 1/60. Notice the high levels of **noise** (the red, green, and blue spots in the details) at this ISO.

emulsion or film, we retained the terminology of **ISO** to determine the light sensitivity of the digital sensor. A low ISO requires a high amount of light to achieve good exposure while a higher ISO does not need as much light to achieve the same exposure.

A word of warning though. When using films with high ISO, photographers saw something we called "grain," small black specks, in the printed image. Some photographers enjoy the look and feel of grain, and the use of grain is actually a creative niche of photography. Unfortunately, using higher ISO settings in the digital camera gives us something similar: *noise*. Since the digital sensor is composed of red, green, and blue components, noise tends to look like red, green and blue spots on your subject; no one wants the multicolored measles. It is far less attractive than grain is. So, try to keep your ISO as low as possible in order to minimize the appearance of noise in the final image.

OBSERVE: AVAILABLE LIGHT

What is the intensity of the light like? Are you outdoors on a bright and sunny day? How bright or dark is the light? Are you indoors at midday standing next to large bay windows? Is the day overcast or rainy? How overcast, how deep is the cloud cover? Is it twilight, even nighttime? How bright is the light?

THE CHOICE – SETTING THE ISO

Which is more important, the reduction of noise or the increased sensitivity to light? In the first case, keep the ISO as low as possible. Most times, you will want to choose to keep the ISO low to reduce noise in the image. If you are selling your work, you especially want to reduce noise to improve the overall quality of the image, which will allow for larger prints being made from the images. However, there are some times when either the noise is a desired part of the image (it gives a specific mood or feel to the image) or you simply cannot get the image otherwise so you have to accept the noise as a result of having the image (for example, if you have to use a short shutter speed to stop a moving subject after dark). Every camera is a bit different on the levels of

noise at different ISO settings. Try your camera out in a variety of different lighting situations to determine your camera's levels of noise and what is acceptable and unacceptable for you and your needs. What is the intensity of the light on location? What is the lowest ISO you can use and still capture enough light for good exposure?

THE TECHNOLOGY: WHITE BALANCE

All light is not created equally. Light actually comes in a multitude of different colors. As our eyes evolved under the bright sunlight, we learned to filter out the various colors so most light looks white to us (remember, there is no reality). The camera has no brain to be able to filter this color change out. It will record light in all its glory and all its colors. Back in the film days we used to have to use colored filters to correct for the colors of light. In the digital camera, we have a *White Balance (WB)* setting to do this for us.

White balance settings usually include sunlight, cloudy, shade, flash, tungsten, incandescent, fluorescent, and auto. Your camera may have more settings than this, so check the manual for all the details on your specific camera. To set the WB, simply tell the camera what kind of light the subject is in. Sunlight is the closest to white light we get, so the WB does little to no correction using this setting (so if you want to retain the wonderful colors of the sunset, use a sunlight WB setting). Cloudy skies create a bluish light while shaded areas create a deeper blue; the camera compensates for these by adding in yellow-orange. Tungsten lights are common in homes and look very orange-yellow on the camera; the camera compensates by adding in blue. Fluorescent lights appear yellowish green to the camera. We will cover the colors of light and WB more in Chapter 4: *Writing with Light* and Chapter 5: *Color Theory and Usage*.

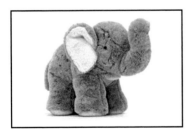

Watch how the color of this small gray elephant changes as the color of the light sources changes. Here, the elephant is in neutral **white light**,

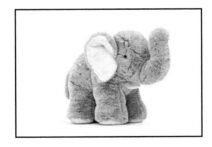

under **fluorescent** classroom lights,

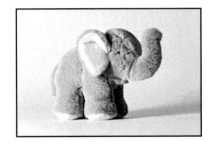

under **tungsten** studio lights,

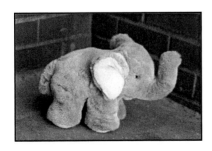

in **mixed** lighting, shade with red from the bricks,

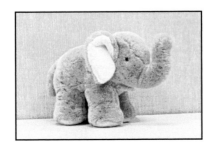

under **fluorescent** commercial building lights,

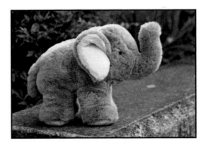

and under a **clouded** sky.

OBSERVE:

What kind of light is your light source? Is it man-made? If the light is artificial, is this a public place (which is more likely to have fluorescent light) or private residence (which is more likely to have tungsten light)? Is it a natural light source? Clouded? Shaded?

THE CHOICE: SETTING THE WB

Choose the WB that is the appropriate setting for the light the subject is in. If the subject sits in the shade, use the shade setting. If you are unsure, you can use the Auto setting.

THE TECHNOLOGY – SHOOTING MODES

Many digital cameras come with the choice of **shooting modes**, which determine how the image is taken: singular, timer, or continuous. **Singular shooting mode** takes one image at a time. No matter how long you hold the shutter button down, it only takes one image per shutter button depression. You will probably use this mode for the majority of your work.

You can also set the camera to **timer**, which allows a brief period of time between the depression of the shutter button and the release of the shutter, usually 2, 5, or 10 seconds. Using the timer can be helpful if you wish to set the camera on a tripod to either 1) ensure no camera shake during exposure or 2) jump in the picture yourself.

Last, many cameras have the ability to record multiple images in a row, one **continuous** series of exposures. The camera itself will dictate how many exposures can be recorded at once and how fast the images are recorded. The continuous mode is great for capturing a "flip-book" type series of images.

CHOICE: SHOOTING MODES

Which shooting mode fits the subject? Are you worried about camera shake? Do you want to jump into the image? Is the subject still enough for the timer or will it have moved in 5 seconds? Is the fast motion of the subject best rendered by a series of fast action shots?

THE TECHNOLOGY: CHOOSING YOUR LEVEL OF EXPOSURE CONTROL

Exposure is the overall brightness or darkness of the final image. Different cameras allow you differing levels of exposure control over the finished image. D-SLRs allow you the most amount of creative control (giving you fully manual aperture and shutter speed settings, which we will discuss more in Chapter 3: *Understanding Exposure Control*), and I recommend that you purchase a D-SLR to fully explore the art of photography. Other cameras, such as the pocket sized PNS cameras, allow you less than full creative control, but still give you choices about how the final image will turn out. Let's discuss the levels of exposure control: Auto, Subject Modes, Program, Aperture Priority, Shutter Priority, and fully Manual.

All cameras have an **Auto** setting, allowing the camera to choose all the settings for you. You merely compose the image and the camera takes care of everything else. It's fast; it's easy; no thinking is involved. However, when there is no thinking involved, you are not involved. The camera has created the image, not you. I do not like automatic settings and recommend that your goal be to control all settings manually, eventually.

Many cameras, especially PNS, give you choices between *subject modes*, the next level up in exposure control. When using a subject mode, you are telling the camera what the subject is in front of the camera and allowing the camera to set the aperture and shutter speed to what is commonly desired for that subject.

Subject modes include settings such as Landscape, Portrait, Sports, Night, Fireworks, Snow, Beach, Pets, Baby, etc. These settings are often denoted by symbols (a face for Portrait, a mountain for Landscape, etc.). Each of these

subjects photograph best with specific internal settings. For example, most landscapes are photographed with a deep *depth of field*, or the most clarity from the front to the back of the image. So, putting the camera in Landscape subject mode will usually give you a deep depth of field.

Conversely, portraits are usually taken with a shallow depth of field, so using the Portrait subject mode will usually give you a shallow depth of field and a blurred background. Sports subject mode assumes

OBSERVE: DOF & MOTION

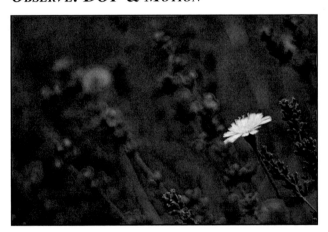
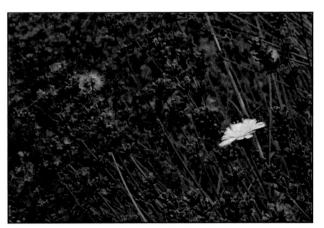

Aperture Priority allows you to change the Aperture size, changing the Depth of Field of the image, how clear the image is from front to back.

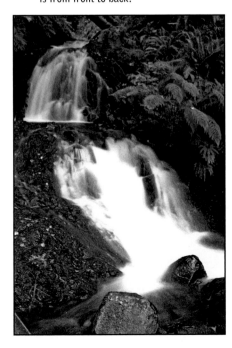

Shutter Priority allows you to adjust the shutter speed of the camera, changing how motion is shown.

that you have fast moving subjects in front of the camera so it tries to stop the motion of the moving subject. Fireworks subject mode does the opposite by allowing the motion of the firework, the full range of the sparks. Night subject modes usually makes the sensor more light sensitive to make up for the lower level of ambient light after the sun goes down. Check your camera manual for which subject modes you may have and what exactly they do.

For fully manual cameras, you have other settings that allow you to adjust the aperture and/or shutter for a wider range of creative options. ***Program Mode (P)*** lets the camera think for you. All you have to do is point the camera and click the button; the camera will decide all the settings for you. Some cameras have various choices within the Program setting that allow you to override some of the camera's choices, giving you a little control over the final picture, but if you are going to have any input, why not just jump into one of the settings that actually allows decent control?

Aperture Priority (A or AV) is the first setting that really allows full choices; it lets you choose your aperture size (the little hole that light travels through to get to the sensor) while the camera chooses the appropriate shutter speed for "proper exposure" (see *The Technology: 18 percent Gray*). This setting is good when you want to choose the specific depth of field effect (see *Creative Effects in Aperture Priority*) in your photograph.

Shutter Priority (S or TV) lets you choose your shutter speed while the camera chooses the appropriate aperture settings for "proper exposure" (see *The Technology: 18 percent Gray*). The shutter covers the aperture, blocking light to the sensor, until the moment you push the shutter release, letting light in. This setting is good when you want a specific rendition of motion (see *Creative Effects in Shutter Priority*) in your photograph.

Manual (M) lets you choose both the aperture size and the shutter speed allowing for minute and detailed changes for maximum creative control over your DOF, rendition of motion, exposure value, etc.

THE CHOICE: BASIC EXPOSURE CONTROL

How much control do you want over the final exposure value (the overall brightness or darkness of the image), the level of exposure control? Auto gives you little to none. The subject modes at least let you dictate the subject you are photographing, but still give you little to no real control. Program can allow you to override the auto, but why not just take it up one more notch? In the Priorities ask yourself: Do I want to control DOF or motion rendition? If the answer is DOF, switch to the Aperture Priority (A or AV) where a Small # = Small DOF; Large # = Large DOF. If the answer is motion, switch to Shutter Priority (S or TV) where <60 (1/60 – 30") is long, will show motion; >60 (1/8000 – 1/60 is short, will stop motion). If the answer is both then switch to Manual for total control.

CONCLUSION

There are a lot of new settings and buttons to learn on the camera. Take it one step at a time. Do not try to learn everything at once as you will get overwhelmed and not learn each setting in depth. Instead, go out and focus on one setting for a whole day or week. Once you have that setting mastered, move on to the next one. Keep doing this until you feel comfortable with the entire camera.

3 Understanding Exposure Control

"No matter how sophisticated the camera, the photographer is still the one that makes the picture." ~Doug Bartlow

Exposure, or ***exposure value***, refers to the overall brightness or darkness of the image. An image that is too dark is ***underexposed***, not exposed enough, because not enough light entered into the camera to render an exposure. An image that is too bright is ***overexposed***; there is too much exposure, too much light coming in to render a good exposure. Since Auto, the subject modes, and Program give you little to no control over your exposure, we will focus on how to best utilize the Priorities and Manual.

CREATIVE EFFECTS IN APERTURE PRIORITY

Each photograph is a 2-Dimensional (height and width) representation of a 3-Dimensional (height, width, and depth) space. The ***Depth of Field (DOF)*** refers to the depth of the photograph that is in focus; you can choose to have the entire 3-D box in sharp focus or have only the single flower that is partway back in the box in focus while the rest of the picture is out of focus. The aperture size is the main setting to control DOF in the image.

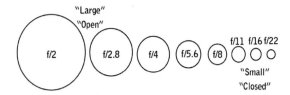

The aperture, or hole, of the lens is measured in *f-stops*, a unit of light that changes in multiples of 2 (the light doubles or gets cut in half), from largest to smallest sized hole.

The aperture hole size in each stop (going from left to right, from large hole size to small hole size) is half the total area of the previous stop, meaning the aperture lets in half as much light. So, f/2.8 is half the area of f/2, f/5.6 is half the size of a f/4 but twice the size as an f/8, f/8 is 4 times larger (2 stops wider) as f/16, f/22 is 1/8th (3 stops smaller) the size of f/8, etc.

A small number/large aperture size (f/2, f/2.8, f/4, f/5.6) will give you a shallow DOF; there will be only a small area from front to back of the image that is in focus. The smaller the number (the larger the aperture size) the smaller the DOF. A large number/small aperture size (f/11, f/16, f/22, etc.) will give you a deep DOF; most or all of the image will be in focus. The larger the number, the larger the DOF. (Note: Many digital photographers are noticing image degradation in the details of images due to light diffraction at the smaller aperture sizes so are now recommending that the smallest aperture size to use is f/16. If you must use a smaller aperture for the DOF you want, then you should check the details for clarity and sharpness.)

There are a couple of things besides the aperture size that also affect your DOF. First, the distance between the camera and subject affects DOF. Depth of field shrinks as the subject comes closer to the camera and increases as distance from camera to subject increases. So a subject 5 feet away will have a shallower DOF than a subject 10 feet away even if they were both photographed at an aperture of f/4.

Second, lenses affect the DOF. Wide-angle lenses have a clearer depth of field; telephoto lenses have less depth of field. The longer the focal length of the lens, the less the depth of field there will be in the image. A wide angle lens set to f/5.6 will have deeper/clearer DOF than a telephoto lens set to f/5.6. The more wide-angle the lens, the more difficult it is to see the shallow DOF effect and vice versa.

Generally, you want to try to use a small aperture (large number such as f/11 or f/16) when you want a crisp, clear picture all the way through. Landscapes are an example of a subject that requires a small aperture. Use a large aperture (small number such as f/2 or f/4) when you want to isolate the subject from the background. Wildlife, portraits, and macros / close-ups usually have a blurred background from a large aperture. These are not unalterable rules, but general guidelines. The important thing is to remember to make a conscious choice about this setting if at all possible so your image comes out exactly as you had planned.

DOF PREVIEW BUTTON

In order to allow enough light through the aperture to see your composition through the viewfinder, cameras default to the largest aperture possible (usually f/2) until the instant the shutter button is pushed when it closes down

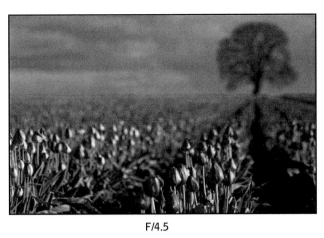

F/4.5

F/5.6

F/8.0

F/11

F/16

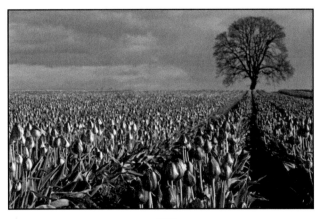

F/22

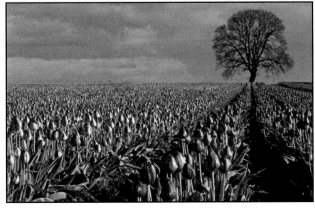

F/32

These images show the different **DOF** associated with different Aperture settings. The focal point stays on the flowers in the foreground, but notice how the clarity deepens as the aperture gets smaller in size (larger in number).

to the aperture size you have chosen. That means that when you look through the viewfinder, you are not seeing the DOF that the final image will have. The **DOF preview button** closes down the aperture to the correct size so you can look through the viewfinder and determine if the DOF is accurate before you take the image. The downside to using the DOF preview button is that the smaller aperture makes for a darker image in the viewfinder, so the effects are harder to see. With the ease of erasing digital images, it may be easier to simply take an image and then evaluate it in the LCD.

MAXIMIZING DEPTH OF FIELD

There are times that you will want to maximize your depth of field, such as in landscape photography, which traditionally has a very deep depth of field. There is a mathematical relationship between the focal length of the lens, the size of the aperture (f-stop), and the depth of field. You can calculate what area will be in focus for any lens at any f-stop OR for any lens at any given distance from foreground to background so you can calculate the necessary size of the aperture to ensure clear focus throughout the image. This concept is called the **hyperfocal distance**.

To bring the entire foreground and background into focus, imagine that the scene in front of you lies within a ellipse or oval with the

camera focusing on one subject within the entire scene. The area of focus that surrounds the focal point in the image is an odd shaped one, not circular but more oval shaped with about 1/3 of the focus in front of the focal point and about 2/3 of the circle behind the focal point. There is a point within every scene that is the perfect spot to focus on to ensure crisp, clear DOF throughout the entire image. This point is called the **hyperfocal point**. The distance from the lens to the hyperfocal point is called the **hyperfocal distance**.

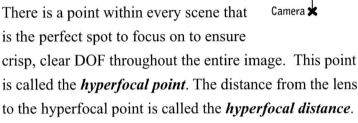

The farthest point in the image is always considered to be infinity, so infinity should be the farthest point in focus in every image, the back of the ellipse of focus. To find the distance from the camera to the closest point in the scene that will be in focus, divide the hyperfocal distance by 2. So, for example, if the hyperfocal distance is 10 feet, then everything from 5 feet to infinity will be in clear focus. The table below shows specific hyperfocal distances for different lens lengths and aperture sizes.

Lens	f/11	f/16	f/22	f/32
16mm	2.9ft.	2.1	1.5	1.0
18mm	3.7	2.6	1.9	1.3
20mm	4.6	3.2	2.3	1.6
24mm	6.6	4.7	3.3	2.3
28mm	9.0	6.3	4.5	3.2
35mm	14	10	7	5
50mm	28	20	14	10
85mm	82	58	41	29

This table shows specific **hyperfocal distances** for different lens lengths and aperture sizes in feet. So, using a 16mm lens at f/11, your hyperfocal distance is 2.9 feet so you should focus on something 2.9 feet into the image to make everything from 1.45 feet to infinity is in sharp, clear focus.

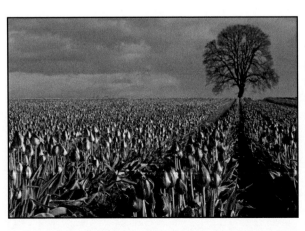

These two images were both photographed using f/32. The one on the left was focused on the flowers in the foreground of the scene while the image on the right was focused using the **hyperfocal distance**.

APPROXIMATING HYPERFOCAL DISTANCE

 Too much math? Too many numbers?
Don't worry. If you don't choose to carry this chart
with you at all times, you can also approximate
your hyperfocal distance. One way to do this is to
focus on an object that is twice as far away from
the camera as the closest object that you want in
the image. So if you want the rock that is three
feet in front of you in the image, then focus six feet
away. If this doesn't work for you, you can focus
approximately 1/3 of the distance into the scene
from front to back by twisting the focus ring of
the lens to manually focus the lens; don't rely on
automatic focus if you are going to do this.

MINIMIZING DOF

 There are times to maximize DOF and there
are times to minimize it. Sometimes a background
is distracting or ugly. There are times that you
want to wash the background out to a blur of color
with no definite form or shape. Doing this requires
a minimized DOF.

 So what factors have we discussed that
affect DOF? Aperture, distance between lens and
subject, and lens choice, correct? A large number/
small hole aperture setting gave us a maximum
DOF so a small number/large hole aperture setting
will give us a minimum DOF. A subject closer
to the camera with more distance between it and
the background will also lower DOF. Macro
lenses allow you to get very close to the subject,
even within an inch, to minimize DOF and bring
out intricate details in life. You can also use a
telephoto lens with its naturally lower DOF to
minimize DOF.

The closeness between the camera and the subject and the
use of a large aperture gives this image a **shallow DOF**.

CREATIVE EFFECTS IN SHUTTER PRIORITY

 The shutter of the camera opens to let light
in to activate and expose the sensor. The shutter
speed refers to how long the shutter is open and
is also measured in stops, from shortest to longest
time interval:

 (Shortest) 1/8000…1/500 ~ 1/250 ~ 1/125
~ 1/60 ~ 1/30 ~ 1/15 ~ 1/8 ~ ¼ ~ ½ ~
1"… 30" Bulb (Longest)

 For each stop (going from left to right) the
time interval that the shutter remains open is twice
as long as the previous stop, meaning twice as
much light enters the camera. So, 1/60 of a second
is twice as long as 1/125 of a second. This makes
sense because if you cut one second into 60 equal
pieces, each piece is bigger than if you had cut the
second into 125 equal pieces. The ***Bulb*** setting
(at the long end of the shutter setting range in
manual mode) allows you to hold the shutter open
indefinitely, which is useful in extremely long
exposures (used in star trails, fireworks, etc.)

The shutter speed controls the appearance or **rendition of motion** in the picture. A slow/long shutter speed lets the subject move more while the shutter is still open, a movement that is recorded in the photograph. A fast/short shutter speed freezes motion into a still frame. Using water as an example, a fast shutter speed would freeze falling raindrops in the sky while a slow shutter speed would let the rain drops streak across the photo, leaving rain trails. Photographing a car race, for example, with a slow shutter speed would show a blur of motion and color while a fast shutter speed would stop the individual cars.

Generally, a longer shutter speed is used creatively for running water shots, creative blurs, and panning effects while the shorter shutter speed is used for sports or on moving subjects. Again, neither is right or wrong, but you must make a choice as to what you want the final picture to look like and then use the appropriate settings to achieve that look.

A Word About Stops

As you may have noticed, both the aperture and shutter settings are measured in **stops**. Photographers use stops to refer to changes in the

1/250 sec.

1/60 sec.

1/30 sec.

1/2 sec.

These images show the different effects the shutter speed has. Different **shutter speeds** render motion in different ways.

amount of light, by a multiple of 2. A +1 stop change indicates that we have doubled (2x) the amount of light entering the camera. A -1 stop change indicates we have reduced the light by half (1/2x). A +2 stop change indicates that we have quadrupled the light (2x2=4x the amount of light), while a -2 stop change indicates we have quartered the light (1/2 of 1/2 is 1/4).

Many cameras these days give you greater control over these settings. Now it is common to see cameras with half or third stops which gives you more minute control over the exposure (but can confuse beginners). If a full stop goes from f/4 to f/5.6, then thirds stops would cut that single stop into 3 settings: f/4, f/4.5, f/5 and then to f/5.6. If you are comfortable with controlling these fractional stops, then they can give you great control over the final image exposure. If, however, you want to keep it simple, stick to learning the full stops and how they interact before working in the third stops.

THE TECHNOLOGY - 18 PERCENT GRAY & TONAL CONTRAST

TONES

Here we need to take a minute and discuss what the camera sees as "proper exposure" because it may not always be what you see or want your exposure to be. Let's imagine the world exists in only black and white for a minute. When you look around the world, you will see that the different colors that once existed in different densities (mint green or forest green) now exist as shades of gray, as tones. Half way between black and white is called *18 percent gray*; it's an exact mix of black and white, an exact mid-tone.

The camera is designed to try to create 18 percent gray in every image. Camera makers program internal light meters to strive for 18 percent gray because they assume the scene you are photographing is composed of brights, darks, and mid tones, so the scene averages out to 18 percent gray. For many scenes, this works out well, but for scenes that have a high concentration of very bright tones (a white fox in snow) or very dark tones (a black panther in a shaded jungle), the camera's creation of 18 percent gray will create a poorly exposed image. The camera will be trying to render your bright whites or dark blacks as medium greys.

TONAL CONTRAST

We measure differences in light intensity in *stops* (a change in the light by a multiple of 2). Reflected light off a white, snowy scene under a cloudy sky will read as 2 stops more intense than the same light source reflecting off a blue, green, or red subject which will, in turn, be 2 stops more intense than a black subject. We refer to this difference in tones as *tonal contrast*, or the difference between the darkest point and the brightest point in the scene.

Ansel Adams created the Zone System that recognized 10 stops of light intensity that black and white negative film can differentiate. Digital cameras are not quite that sensitive yet. Your eyes can see up to about 14 to 16 stops of light (more if you count the fact that our pupil adjusts when we look around the scene. Even the cameras with the widest range of tonal values do not equal that of our eyes.

This means that tones that are about 18 percent gray will record in the image as accurate to your eye, but any area that is even as little as 1 stop overexposed or underexposed will have faded details and a wider range of contrast in comparison to what the eyes sees (more highlights and deeper shadows than you remember being there). Anything that is 2 stops overexposed or underexposed will have no detail. A scene with a full moon over a dark landscape can have a range of up to 18 stops of light intensity difference. Your image will expose as a white moon with a black sky and no in-between detail, while the eye may have been able to pick out details while you were taking the image.

Using reflective light values works great in indirect or diffuse light. When you are in harsher, direct light, though, you will get glare – all the colors will seem brighter (and the lighter the color the more the chance for glare) which can also throw off the camera's light meter.

What does this mean for you? Be aware that the camera's meter may fail so don't take the camera's suggestion as gospel. The camera is trying to make your image 18 percent gray, which works perfectly if the scene you are photographing averages out to 18 percent gray but if the scene is composed of mostly bright or dark tones, you will have to compensate for the poor exposure (overexpose or underexposure of the image).

The scene may have a tonal range that exceeds the camera's ability to record, which could also throw off the exposure. Also remember that there are several ways to meter the scene in front of you. If you have a spot meter, or if you use the spot meter in the camera's metering modes (see Chapter 2: *The Digital Camera - Settings and Features* for more information on in-camera light meters), you should use it to test several different sections of your image so you can know what falls inside or outside the range of your camera's abilities, therefore choosing what you want to expose for and what may be overexposed or underexposed. If the camera does not produce the exposure or effect you want, adjust and re-shoot. That's the beauty of digital cameras.

THE CHOICE - EXPOSURE BRACKETING / COMPENSATION

Now there may be times when the exposure for 18 percent gray is not what you want for your image. If you tried to photograph a white arctic fox on white snow, you would record a gray fox on dingy snow. Now imagine a sleek black panther creeping through the deep shadows of the jungle. The camera would try to make that deep black panther into a middle gray panther lounging in the shade.

Exposure bracketing refers to a technique where you expose 3-5 images of the same subject and composition, each slightly different in exposure value to ensure you have at least one exposure that you love. Usually when you bracket your images, you take one image at "proper exposure," then one each at 1 and 2 stops overexposed and underexposed. So, you would take a series of images starting at 2 stops underexposed, then 1 stop underexposed, then 18 percent gray exposure, then 1 stop overexposed, and finally 2 stops overexposed for a total of 5 images, all slightly different exposure values. Many digital cameras can bracket automatically for you with Auto Exposure Bracketing (AEB) in the menu section. With multiple exposure values to choose from, you can determine which is best for the image you are creating.

Exposure compensation allows you to chose to bracket one way only, going only positive or only negative. Let's say you want to photograph a white on white subject, but you do not know exactly how

Exposure compensation allows you to compensate for the camera's poor exposure in extreme situations. This white on white scene was rendered as 18 percent gray instead of pure whites (far left). By increasing the exposure compensation by +1 (middle) and +2 (far right) I was able to bring up the whites.

the camera will record the whites. You can take a test shot at the camera's suggested settings, notice how it is a bit dark, the whites are middle gray. Using the Exposure Compensation, retake the image at +1 and +2 stops exposure and see the differences of the brightness of the whites. Using Exposure Compensation instead of the AEB allows you to adjust in the correct direction without having to waste memory space on further underexposing an already dark image.

While there is something to be said about fully controlling every setting on the camera, in reality, if you can get proficient in using aperture priority and shutter priority, and in utilizing the exposure compensation setting, you may never need to step into fully manual exposure mode. With these combinations of settings, you have a great deal of control over your final exposure and effects.

The Technology - Understanding Manual Exposure

In the Priorities, the camera still controls some of the settings. There will be times when you want to take full control over your settings. You can manually adjust the amount of light that enters the camera in several ways. Understanding fully manual exposure relies on understanding three interacting variables: the aperture size, shutter speed, and ISO setting. The first two relate closely together, so we will discuss those first; then bring in the third.

First, let's imagine for a minute that we're out in the yard, trying to fill up a very large bucket with water. We have several different hoses that we can choose from to fill up the bucket. Each of these hoses has a different sized opening. This "hose size" represents the aperture size of the camera. The *aperture* is the hole in the camera that light passes through to reach the camera's sensor. We refer to aperture size as small / closed or large / open.

Next, we must imagine water flowing into our bucket from each of the different sized hoses. You want to fill the bucket exactly to the top without overflowing or leaving empty space in the bucket. Depending on the size of the hose, it will take a different length of time to fill the bucket. The amount of time it takes the water to flow through the hose to fill the bucket represents the shutter speed of the camera.

The **shutter** is the piece that sits between the aperture and the sensor, blocking light to the sensor. The shutter stays closed and in place until you press the shutter button on your camera. The **shutter speed** indicates how long the shutter is open, allowing light to pass through the aperture and onto the sensor. We refer to shutter speeds as long or short. You can think of an eyelid blinking, except that our eyes remain open until the split second the lid closes while the camera is opposite; the shutter stays closed until the split second you open it – it is a backwards blink.

To complete our example, the filled bucket represents a properly exposed photo. You want to make sure you "fill" the photo with enough light to avoid over-shadowy areas but without "overflowing" your photo with light causing overexposure. Overexposure happens when too much light has hit the sensor (too much water overflowing the bucket). Underexposure happens when not enough light reached the sensor (the bucket did not fill all the way to the top).

Just as we could fill the bucket with a combination of different hoses and fill times, we can also achieve proper exposure from a variety of different combinations of aperture size and shutter speeds. When the camera thinks for you, it will choose the aperture size and shutter speed. Many cameras have settings that allow you to control the aperture size and shutter speed. You can learn photography with any camera, but a great deal of the creative aspects of the art of photography requires the ability to control these settings. If your camera does not have adjustable settings, then you can master the other aspects of photography until you can get a camera with adjustable settings. Eventually, as you get better and more serious about your art, you will want more control over these settings.

CHANGING SETTINGS, KEEPING EXPOSURE CONSTANT

Going fully manual simply means that you are controlling both the aperture and the shutter yourself and not leaving either up to the camera, which does not mean you cannot use the camera as a light meter and a back up to check your figures. That is the beauty of digital.

Remember, exposure is the overall amount of light entering the camera and activating the sensor. The specific combinations of aperture size and shutter speed that creates proper exposure will vary based on the subject, lighting conditions, desired effect, etc. Light can enter from either the aperture (the hole size – how much light is let in at one time) or the shutter speed (how long light is let in). Once you have a basic meter reading, changing settings while retaining exposure becomes a matter of "what you take from one, you must give to the other."

Let's work through an example. We arrive at a scene and set up a composition. We take get light meter reading. We can do this one of several ways. We can either a) use an external light meter, b) use the camera's internal meter, or c) use the Sunny Rule of 16 to estimate exposure (see *Sunny Rule of 16* later in this chapter). An external light meter is the most reliable and can usually be used to meter both incident light and reflected light (see Chapter 4: *Writing with Light* for more on types of light), which makes it a more useful tool. However, it is an expensive piece of equipment and one more thing to carry around with you. You may find the camera's internal light meter suits your purposes. To use the camera's meter to get a starting point, simply put the camera into Aperture Priority or Shutter Priority with the appropriate initial setting dialed in. Push the shutter button

halfway down and the camera will meter the scene and suggest a second setting for you. Remember those settings and use that as your starting point in fully manual.

However we choose to get our initial reading, put the camera into Manual with your initial settings dialed in, for example, if you have a situation where f/8 at 1/250 would create proper exposure. Now "where you take from one, you must give to the other." If you want to reduce the DOF by 1 stop, you would change the aperture (which controls DOF) one stop from f/8 to f/5.6. This adjustment opens up the aperture to twice its size, letting in twice as much light. To compensate, you must reduce the shutter by one stop, from 1/250 to 1/500, reduce the amount of light let in by half, balancing the light back out.

If you wanted to change the scene to show more motion, to go from a 1/250 shutter speed to a 1/60 shutter speed, which would let in 2 stops more light or four times as much light as the original settings. To compensate, we have to close down the aperture 2 stops, from a f/8 to f/16. This retains the whole, overall exposure while allowing you to change the visual effects in the composition.

Once you know which settings would result in a properly exposed photograph, you can begin to make your decisions about what effects you want to achieve. If you want motion blur, choose settings that have a longer shutter speed. If you want shallow DOF, then use settings that have a large aperture.

ISO

So, we have discussed the aperture and the shutter and how they interact with each other to create overall exposure, but didn't I say that understanding exposure meant understanding three things? So what is the third and how does it interact with the previous two?

The ISO of the camera refers back to the technology of film cameras. Film itself came in different "film speeds" (25, 50, 10, 200, 400, and 800), which measured the film's sensitivity to light. A "low speed" film like ISO 25 or 50 was not very sensitive to light, meaning it took more light to activate the chemicals on the film and achieve proper exposure than a "high speed" film like 800 would take. A high speed film required much less light to activate the film, but it gave up some clarity in the details of the photograph and had grain. Each speed differed in sensitivity from the adjacent speeds by 1 stop (the same measurement used to describe the light differences in the aperture and shutter settings.) So, an ISO 200 is one stop more sensitive to light than an ISO 100.

Film cameras are designed to automatically read the film's ISO (from a barcode on the film canister) and set the camera to the appropriate settings. Digital cameras still have ISO as a changeable setting even though there is no film for the light to activate. This term now relates to how light sensitive the camera's sensor is. An ISO setting of 100 is not very light sensitive; it requires a lot of light to activate the sensor, whereas a ISO of 1600 is very light sensitive; it can pick up even small amounts of light.

Your ISO is the third aspect of exposure. For the most part, you want to keep the ISO as low as possible for the best quality of final image. However, if you find that you are in an extreme light situation (especially if you have very low light) it may be worth while adjusting your ISO to compensate.

If we return to our original metaphor of filling a bucket with varying sized hoses at varying lengths of time, the ISO would be the size of the

bucket itself. How much overall water is needed to fill the bucket? How much overall light would be needed to create a good exposure? At ISO 100, a lot of light is needed; the bucket is very big. At an ISO of 1600, only a small amount of light is needed; the bucket is very small.

A word of caution, though, about your ISO setting. Do you remember when we used film, the downside of the higher ISOs were grainier images? There is a similar downside to the higher ISO on the digital camera. Now we have **noise**. Grain could be attractive, like black speckling on the image; it was even deliberately used sometimes for creative effect. Noise is not so attractive. Since the sensor is composed of red, green, and blue components; noise is red, green, and blue spots. The higher the ISO setting goes, the more noise will show up. You have to determine what are acceptable noise levels for you and your needs. In general, though, try to keep the ISO as low as possible to reduce noise.

Overexposing and Underexposing for Creative Effect

Sometimes adjusting the normal, everyday camera settings, even minimally, can enhance the mood of a scene. Slightly overexposing or underexposing an image helps to bring an emotional response from the viewer. Overexposed images look bright and happy, whereas underexposure can make darker, moodier images. Try capturing multiple exposures of your scene to see which exposure best suits your image.

So far, we have discussed changing settings manually to change effects but maintain the overall exposure value. Now, let's manually over- or underexpose. We do not have access to the Exposure Compensation settings in fully manual, so we have to compensate manually. When we want to keep exposure the same while changing settings, where we give to one, we must take from the other. To change the exposure itself, simply change one setting and leave the others alone. So, if we had mid-toned exposure at f/8, 1/125, and ISO 100 and we want to overexpose by one stop, brightening the image up, we can adjust either the aperture (going to f/5.6), the shutter (going to 1/60), or the ISO (going to 200), but only one of them. This will let in more light overall.

Sunny Rule of 16

If you are having trouble with exposure or do not have a working light meter, a good estimation guideline is the **Sunny Rule of 16,** which states that on a bright and sunny afternoon, an aperture size of f/16 and a shutter speed of 1/ISO (since we are using a standard ISO of 100 use shutter speed of 1/100 for the Sunny Rule of 16, but if our ISO was at 400, then use shutter speed 1/400) will result in proper exposure. This rule lets us estimate good exposure. Based on this rule we can set some general guidelines for exposure. Remember these are just starting points, and should be checked for your desired effect. Make the conscious choice as to what the final photo will look like.

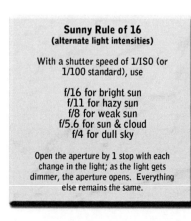

Sunny Rule of 16
(alternate light intensities)

With a shutter speed of 1/ISO (or 1/100 standard), use

f/16 for bright sun
f/11 for hazy sun
f/8 for weak sun
f/5.6 for sun & cloud
f/4 for dull sky

Open the aperture by 1 stop with each change in the light; as the light gets dimmer, the aperture opens. Everything else remains the same.

The Choice: Level of Exposure Control

What levels of exposure control does your camera offer? What levels are you comfortable with? Auto? Subject modes? Aperture priority to control DOF? Shutter priority to control the rendition of motion? Do you need exposure compensation? Do you want to bracket? Are you up to trying fully manual to control it all?

Conclusion

There are three main camera settings that can affect your exposure: aperture size, shutter speed, and ISO. Each of these adjustable settings changes the amount of light reaching the sensor by a factor of two (either half or twice as much each time), which is called a stop. When you let more light in on one of those settings, you must reduce the amount of light let in on another setting to achieve the same exposure. To over- or underexpose manually, simply adjust one setting without moving the others, allowing more or less light in without compensation.

Ultimately, exposure is what you want it to be. Normally exposure is considered proper if it accurately represents what you visually perceived. However, you can deliberately over- or underexpose your photographs to achieve specific creative effects. There is no right or wrong. The trick is to achieve the exposure that you meant to achieve.

'

4 Writing with Light

"The moment you take the leap of understanding to realize you are not photographing a subject but are photographing light is when you have control over the medium." ~Daryl Benson

When broken down to its Latin roots, the word "photo-graphy" literally means "to write with light." With every image you ever take, every picture you create, every smile you capture, your real subject is the light. Light is everything in photography. Without light there is no image, no exposure. Light can make a landscape come to life or destroy a perfect moment in time. Learn to watch the light, study light, and love light in all its forms. Since we are studying an art that uses light as its main subject, we must know a little about the properties of light before we can understand how to use it to create our art. In the studio you have luxury (or curse) of having complete control over lighting, but in nature you are often at the mercy of the environment. This chapter will focus on natural lighting and minimal equipment.

THE SCIENCE: THE ELECTROMAGNETIC SPECTRUM

First, for some basic physics. The sun puts off radiation, or energy, that travels in waves in tiny bundles called photons to the earth. An electromagnetic field surrounds each photon with a

separate electrical and magnetic field which each fluctuate around the photon, perpendicular to each other (see Figure 4.1). All photons move at the same rate, but the rate of fluctuation of the electromagnetic field may change; the more energy the photon has, the faster the fluctuations. We see this change as different colors – red light has less energy than blue light.

Figure 4.1 - An Electromagnetic wave with an electrical component and a magnetic component that fluctuate around the photon.

We measure the different rate of fluctuations in wavelengths, measured in nanometers (nm.). A **Wavelength** is the distance between two corresponding points on two successive waves. The full range of wavelengths lie along the **Electromagnetic Spectrum** (which is the way we classify these different wavelengths.)

The entire Electromagnetic Spectrum of radiation hits the earth, but we can only physically perceive some of it, while we have specialized machinery to read other portions of it (such as televisions, radios, and some cameras that can read infrared and UV rays). This radiation can range from gamma rays at only 1/100,000,000nm to radio waves, which are 6 miles long. The human eye can only perceive wavelengths that range between 400nm (the color violet) and 700nm (the color red.) When we see all these radiation wavelengths at one time, we perceive a white, neutral light. Cameras are sensitive to other forms of light that the human eye cannot perceive, for example, UV radiation (which is why using **UV filters** can help to eliminate the degrading UV rays that you can't see but the camera records).

As photographers we are mainly concerned with the 1) *Quality of light,* which is determined by the size of the light source. The quality of light also affects tonal contrast; for example, light rays from a small, hard light striking the subject at the same angle creates high contrast while light rays from a large, soft light striking from multiple angles creates low contrast; 2) *Direction of Light,* whether top, side, front, back, or some combination thereof; 3) *Color of light* – "White" light is an even mix of blue, red, and green light which is perceived as colorless; and 4) *Intensity of light,* where the brighter the better.

OBSERVE:

OBSERVATION 1) QUALITY OF LIGHT – HARD VS. SOFT
Hard or specular light refers to a small light source with nothing between the light source and the subject. This creates higher tonal contrast, the

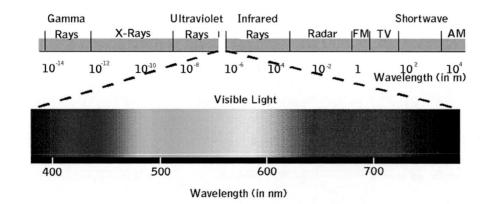

The Electromagnetic Spectrum.

Hard light, left, comes from a smaller light source and produces hard edged shadows. Soft light, right, comes from a larger or diffused light and produces softer shadows and wrap-around light.

difference between the darkest dark and the lightest light, as all the light hits the subject from relatively the same angle creating bright highlights opposite dark shadows. Your eyes can adjust as they search the scene, constricting the pupils in brighter areas and expanding the pupil in darker areas. The camera cannot do this so there is more a noticeable difference in the highlight to shadow range in the print.

Hard light also creates sharply defined edges on objects with bright highlights, deep shadows, and few mid-tones. This light is bold and aggressive. It represents energy, vitality, and heat and is better for landscapes than anything else. However, hard light can create some truly unflattering portraits, so we prefer softer light when working with people.

Soft or diffuse light is light hitting the subject through a diffusing layer, such as fog, smoke, haze, clouds, or fabric, such as silk and/ or nylon. This changes the size of the light source from the light (or sun) to the size of the diffusing material (such as a sheet or cloud cover) making the light much bigger in comparison to the subject and producing lower tonal contrast, much more friendly

to the digital camera's tonal range. It produces a soft edged shadow, a shadow that fades out instead of ending abruptly, hence the name "soft light." As the light is diffused, the light rays scatter, splitting off into different directions, giving a wrap-around lighting effect, producing richer colors. This light is emotionally non-aggressive and quieting. It suggests coolness and peacefulness. This light is better suited for portraits, wildlife, macros, or intimate scene shots.

In situations when you have a single light source, the size of the light source—not the physical size but the effective size to the subject—is the primary influence for the quality of the image. For example, the sun is huge but so far away that in relation to a subject here on Earth, the sun is very small. Also, small lights are always hard lights while large lights are softer: the larger the light, the softer the light. An overcast sky becomes a huge light source that fills the sky and produces very soft light. You can read the shadows to determine what type of light you are in. Shadows with hard, definite edges come from hard light while shadows with graduated edges or soft shadows come from soft light.

If the light is too hard, creating more tonal contrast than the camera can handle, you can modify the light. You can change hard light to soft light by putting a diffuser, or some sort of sheer material, between the light source and the subject. You can also introduce a reflector, material that reflects some of the light back the direction it came, to the shadow side to even out the light/dark ratio. A fill flash may also reduce the tonal contrast, but be careful not to over flash the subject creating the appearance of two light sources. Since we have only one sun, having two sources looks odd or unnatural to us. You can reduce the amount of light your flash puts out with the **Flash Compensation** setting (check your manual for more information).

The Choices:

What is the quality of light are you working with? If it is hard light, is the light and tonal range too much for camera? Is the light good for the subject? Does it need modification? What can you modify with? Diffuser? Reflector? Fill flash?

Observation 2) Direction of light

Front light is light used from straight on. This type of light ensures that you can see the subject by filling in all the shadows. However, since we perceive depth and dimension by reading shadows, front light flattens out any details as there are no shadows. Front-lit subjects would be facing into the rising or setting sun (or other light source) while the sun is behind the photographer. There is the old adage "photograph with the sun over your left shoulder" which would give you frontal light. While this would work to record what is there, it is unflattering, both to natural subjects and to people (who also tend to squint when faced with front light).

Side light skims across the subject, highlighting the sharp lines but softening over other features. Sidelight creates shadows and texture to enhance depth perception. Sidelight naturally happens as the sun is low in the sky, either at or soon after dawn or just before and at dusk. Window light can produce pretty side light for indoor subjects.

Back light produces the most contrast. Back light has the definition of sidelight (it will outline your subject) and the harsh contrast of high noon front light (which flattens subjects to 2-dimensions)

> **Technical Tip:**
> Make sure you expose for the shadows as this makes the rim lighting overexposed and the side lit or back lit part of the image more vibrant.

> **Technical Tip:**
> Try using a fill flash (reduced in intensity using Flash Compensation) or a reflector to lighten the front of the backlit subject.

The **direction of light** dictates how the light shows the shape of the subject, especially faces. Full **front light** (far left) flattens out the face, showing little to no shadow and, therefore, little to no depth in the face. The face looks as wide and flat as it can. In **side light** (middle) the shadows conceal half of the face, thinning the face to an extreme. For a more flattering light, try a high light source that is between front and side (like **Rembrandt light** - far right) which shows the shape of the face nicely.

this makes the subject often appear as a silhouette. If a subject is translucent, backlighting will make it turn transparent.

Top light is light originating from above. Some subjects, including people –look horrible in this type of lighting (think raccoon eyes). Other subjects, such as canyon walls, can be defined best by top lighting. Top light on a vertical textured subject will become sidelight to the subject and will show off the texture of the subject, such as a canyon wall.

You can also use a light that has a combination of directions, such as front-side light or 45degree light. This light is neither pure front nor pure side light but rests directly in between. If you move that light up, you get a popular portrait lighting style called *Rembrandt lighting*.

If there is no direction to the light, in very overcast or diffused light conditions, we can add some direction to the light by introducing a reflector. The reflector will focus light in one direction, one that you choose by rotating the reflector around.

If you are unsure about the direction of the light, read the shadows. The shadow will lie opposite the light source. A longer shadow indicates a more side light source while a short shadow indicates a more top light. If you can't see the shadows, then read the catchlights (highlights) in eyes or in the image in general to determine the light position relative to the subject.

THE CHOICES:

Is the light moving in a flattering direction for the subject? Can you change the light source position? Will moving around the subject change the light's direction? Can you move the subject into better light? Does the light need modification?

OBSERVATION 3) COLOR OF LIGHT
COLOR TEMPERATURE

Color temperature is the common way of describing the main color changes that light goes through. We are not talking about the physical temperature of the light; light itself does not heat or cool, but it does turn colors that match those on the color temperature scale. These color designations lie on the **Kelvin scale** and are referred to as color temperature.

The Kelvin scale is based on the work of a physicist named William Thomson, 1st Baron Kelvin who heated a "blackbody radiator" (a black piece of matter that can absorb all radiation striking it) and recorded the color the radiator turned as it was being heated. This experiment can be replicated today. As the radiator is heated, first you will see a dull red glow, then orange, yellow, and white heat. Finally, the radiator will turn blue.

The colder temperatures are yellows and oranges; the hotter temperatures are blues; while the Kelvin scale may seem to oppose the idea of warm and cool colors on the color wheel where warms are reds, oranges, and yellows and cools are blues and purples, if you compare these colors to a flame, though, you will see this makes sense, as the outside of the flame, the coolest part, is yellow, the middle is white, while the inner, hottest portion, is blue.

Natural light also varies greatly from artificial light in terms of color temperature. As the day progresses, the light changes in color temperature as well. For example, the closer the sun is to the horizon, at dawn or dusk, the more yellow or red the color temperature is because the light has more atmosphere to travel through and the shorter blue wavelengths get lost in the

Remember our elephant under **white light**,

in **mixed** lighting, shade with red from the bricks,

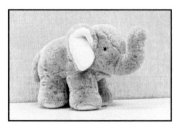

under **fluorescent** commercial building lights,

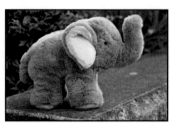

and under a **clouded** sky?

shuffle. Morning light is yellowish, more so at dawn and less until midday. The sun, at its zenith on a clear day, is referred to as "white light." Our eyes evolved under the midday sun, so our eyes grew to see sunlight as "neutral." Cloud cover changes the light to a bluer light as the longer red and yellow wavelengths are absorbed into the water particles in the air. The more clouds are present, the more blue the light. Moonlight is blue-tinged (with the moon itself yellow or reddish only when it is close to the horizon.)

Even reflected light can affect your image. On a bright day with a brilliant blue sky, the blue light will reflect into the shadows making them and whatever is in those shadows look blue. For example, if you are photographing a patch of white wildflowers in the shade, the reflected light will make them look blue. If you want to capture shaded green grass, that grass will actually have a greenish-blue hue. Warm, morning light when reflected on blue flowers will change their hue to a yellowish-blue hue.

Well, that's very nice, but why does this matter? Your eyes will automatically adjust for these light subtleties (remember there is no reality, only how you perceive the world around you) but, in photography, the digital sensor will record what is actually there. Your eyes will view a white shirt under Tungsten light, daylight, and overcast light as a continually white shirt, an effect called color constancy, but the camera will record a yellow shirt (Tungsten), a white shirt (daylight), and a blue shirt (overcast). You need to be aware of these color shifts so that you can adjust for them so that your final picture has the effect you are looking for. In digital cameras there is a feature called *white balance* where you can correct for these color shifts.

Common Light Sources & Corresponding Kelvin temperatures.

Clear blue sky	Varies 8000-27000K
Misty daylight	7200-8500K
Overcast	6500-7200K
Electronic Flash	6200-6800K
Fluorescent – bathroom or indoor business lights	
Daylight balanced	6500K
Cool white	4300K
Warm white	3000K
Tungsten – living room lights – yellow	3200K
General Purpose lamps (200-500w)	2900K
Household Lamps (40-150w)	2500-2900K
Sunrise / sunset	2000-3000K
Candle flame	1800-2000K

This Mr. Potato Head sits under Tungsten studio lights. First, I used the Daylight WB setting to show the color of light as the camera sees it. Second, I used the Auto WB setting. Third, I used the Tungsten WB setting. Lastly, I took a custom WB reading and used the **Custom WB setting.**

WHITE BALANCE

When working with film, photographers have to recognize which type of light is present and then correct for it with colored filters. With digital cameras, we use the ***White Balance (WB)*** feature to correct for lighting color changes. The WB feature uses symbols to represent the main lighting choices: daylight, cloudy, shade, tungsten, incandescent, fluorescent, flash, and custom. Simply set the WB setting to the type of light the subject is in (if you are in the sun, but the subject is in the shade, set to shade). The custom setting allows for minute adjustments to the color of light.

For those who have ever lived in the Pacific Northwest, you know that there are differing levels of "cloudy" and one setting cannot cover them all. The WB settings are generic settings. If you wish to get more specific, you can experiment with the Custom WB (check your manual for the exact directions on how to use your specific camera). Many cameras also come with the ability to dial in custom Kelvin temperatures for the light you are in, which can allow for increased creativity in the rendering of your colors.

If you want to keep the beautiful colors that you see in the sunrise or sunset, then keep the WB out of auto, which will filter that color out. Instead put the camera into daylight WB, which does the least amount of filtration. This should give you the most accurate color unless you want to use a custom setting.

This gravestone was under a cloudy sky, so I used a Cloudy WB first, then switched to Shade WB first, Tungsten WB second, and Fluorescent WB third to add in some **unique WB color.**

So far we have discussed using your white balance for a corrective measure, to correct out the color casts of light. Your white balance can also be used in a creative measure. If there is no color to the light, you can add some in (Peter Jackson's _Lord of the Rings_ trilogy made adding in colored light very popular - think of the differences between the two lands of Rivendell and Moria). Think for a minute, tungsten light is yellow-orange, and you know that the camera will compensate for and correct out that yellow by adding in blue. Now, when using a white light source, the camera (if set to Tungsten) will add in blue trying to compensate for light that does not need compensating, giving a blue color cast to the final image. You can add in color that does not exist for an ethereal or otherworldly look.

ARTIFICIAL LIGHTING

We focus on natural light, but you should be aware of the effects of artificial light, both indoors and outside, that can affect your photo. When artificial and natural light mix, it creates problems for your white balance. Mixed lighting is difficult to correct for, so avoid it if you can (try turning off the interior lighting to have solely natural lighting or closing a window to have solely interior lighting). Tungsten lights (private, in-home lights) look yellowish, fluorescent (public places such as indoor businesses) or mercury vapors (street lights) look blue green, and sodium vapors (street lights) look yellow-orange. Neon, illuminated signs (like the ones that hang on walls) will photograph as the eye sees them.

Technical Tip:

When photographing illuminated signs, the light actually flickers on and off so you need a shutter speed of 1 second or longer to catch several flickers.

Your white balance setting can correct these color changes relatively easily. Simply tell the camera what type of light the subject is in, and the camera will compensate for those colors. If you still see color you want to remove, check your manual for more information on your camera's custom white balance settings that allow you to custom create a white balance for the specific environment you are in.

The color of incident light can change dramatically throughout your photography locations, which affects your final image. To see the true colors of the subject, you must account and correct for these color-casts from the light source.

THE CHOICES:

What color is the light? Do you want to filter that color out? What WB setting do you want to use to filter out that color? Do you want to keep the color of the light that you see? Or, do you perhaps want to add in color that does not exist except in your imagination?

OBSERVATION 4) BRIGHTNESS / INTENSITY OF LIGHT

As a general rule, the brighter the better when it comes to light intensity. Illumination declines predictably as the distance between the light source and the subject increases. We can mathematically measure this effect with the **Inverse Square Law,** which tells us the reduction or increase in

Inverse Square Law

The intensity of the light is inversely proportional to the square of the distance.

So, a light that is 2x as far away will look ¼ as bright

OR

a light that is close will be 4x brighter than one that is 2x as far away).

illumination on a subject is inversely proportionate to the square of the change in the distance from the point source of light to the subject. Whew! That was a mouthful. Simply put, the Inverse Square Law means that as the distance doubles (2x), the light quarters (1/4) because with more distance between the light and the subject, the same amount of light is spread over a larger area. This formula is not relevant to the sun, however, as the sun is so far away that any positional change of the subject here on earth is minute relative to the position of the sun. The sun shines infinitely bright, with no fall off. Window light does have fall off, on the other hand, as the window is providing the light, not the sun.

COMPENSATING FOR LOW LIGHT

Generally speaking, when you are faced with lower ambient light than is ideal, you have a few options. First, and wisest, is to bring along a tripod. Remember, exposure is a combination of aperture size, shutter speed, and ISO. The aperture can only open so far and doing so reduces DOF, whereas rasing the ISO increases digital noise. Neither setting is ideal to give a wide range of options. With a tripod, though, you can leave the shutter open for longer periods of time, allowing more light to enter and exposure to be achieved even at apertures such as f/8 or f/16, which will still give deep DOF while retaining a lower ISO.

Since the camera is on the tripod and clarity is important, you can also invest in a **remote shutter** for your camera. A remote shutter plugs into the side of the camera and allows you to fire the shutter without physically touching the camera, reducing camera shake to minimal.

A second option is to use a flash or other light to add more light onto the scene. This can make the scene look overly "flashed," though, so watch out that you do not add too much light. You can turn down the amount of light the flash puts out by using the Flash Compensation feature of the camera.

These images were all taken during **low light**. In the first image, the shutter was allowed to stay open for 1.6 seconds to let in enough light to get good exposure and keep the ISO low (notice how there is no noise in that image). The second image was taken with an ISO of 12800 to allow the shutter speed to come down to hand-held speed: 1/60. Notice the high levels of noise (the red, green, and blue spots in the details) at this ISO. The third image used a flash to add to existing light which shortened the shutter speed (but not to handheld speeds, the camera still needed a tripod).

If you choose not to carry your tripod and you don't like the flash, you can increase the ISO to increase the camera's light sensitivity to be able to keep the shutter at handheld speeds (1/60 or faster). Be aware that higher ISO levels create higher levels of noise, though.

THE CHOICES:

Do you need to compensate for lower light levels? You can either 1) use a longer shutter speed and a tripod for stability to allow enough light in, or 2) use a higher number ISO, which will increase the light sensitivity of the camera, making it easier for the camera to detect what light is there, but watch out for noise, or 3) add in light with flash or strobes or some other light source.

> **Technical Tip:**
>
> Auto-focus requires tonal contrast to focus properly, so low contrast situations may require manual focusing.

What if the light is too bright and overexposes the image at the shutter speed you want to use? Try a neutral density filter to block some of the incoming light and darken exposure again.

Tonal Contrast

The difference, or range, from the lightest to the darkest areas of the photograph is referred to as *tonal contrast*. Tonal contrast is affected by the intensity and the quality of light. When the sun is high in the sky, the intensity of the light is high and the light is all going one direction so the tonal contrast increases. When the sun is low to the horizon or when clouds cover the sky, there is less intensity, a more scattered light, and less tonal contrast.

Your human eye can adjust itself as you scan your environment, your pupil constricting in bright areas and expanding in dark areas. Your eye can adjust much more so than digital cameras, which are not able to accurately record more than 5 or 6 stops of light difference. That means that if the brightest area requires a camera setting that is more than 6 stops away from the setting that the darkest area in the photo needs, then one of the two will not come out right. You can use a spot meter to read the highlight exposure value and compare it to the shadow exposure value to see if the range falls within the camera's abilities. If the range of tonal contrast surpasses the camera's abilities, you must choose which to expose for, the highlights or the shadows.

THE SCIENCE - HOW LIGHT INTERACTS WITH THE SUBJECT

Photographic light is more than just light; it is a relationship between the light, the subject, and the viewer. First, the light must interact with the subject. Then, to make stunning imagery, it must interact with the viewer, giving the viewer an emotional reaction. The subject affects how the light appears to the eye; the subject can do one of 4 things: transmit, absorb, reflect, or scatter the light.

When light *transmits*, the light passes through without modification (through air or clean glass, etc.). In *direct transmission* the light passes through in a predictable path, such as through transparent materials. In *diffuse transmission*, the material scatters the light rays in unpredictable directions, such

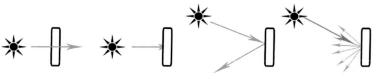

Transmission Absorption Direct Reflection Diffuse Reflection

as through translucent materials. True 100 percent transmittance is invisible, un-photographable, but only happens when the light hits the subject at a perpendicular angel to the subject (90° angle). At any other angle, the light rays are *refracted* (bent as they pass through the material), which can be photographed; *refraction* causes a change in the speed and direction of the light ray (denser matter means slower movement) but the light regains its speed and direction once through the material.

Absorption happens when the light energy is absorbed by the subject and never seen again, usually released as heat energy. Total absorption cannot be photographed, either. Luckily most subjects absorb some and reflect some of the light (which is the determining factor in the perception of color). The level of absorption determines if we see the subject as dark toned, mid toned, or light toned. Black velvet is very absorbing, whereas white snow is very reflecting.

Reflection happens when light strikes and bounces off the subject. Here *the angle of incidence is equal to the angle of reflectance* meaning the angle that the light enters is the same angle that the light will leave the subject. Most objects do not produce their own light source, so they are only visible from the reflected light bouncing off of them. Photographic lighting is an exercise in light reflection management, as subjects can reflect light differently.

Direct reflections / specular reflections are a mirror image of the light source, usually from a polished subject like metal. The light rays bounce from a smooth surface at the same angle that they hit – the angle of incidence equals the angle of reflectance. The brightness of the direct reflection will remain the same regardless of the distance from the light source, whereas the size of the reflection does change with the distance – a larger light source fills the family of angles from the light source that causes direct reflection on the subject, giving a full reflection from every angle.

Diffuse reflection / scattering light happens when the subject has the same brightness regardless of the angle it is viewed from; the light is reflected equally in all directions. This light is reflected in all directions because the light hits an uneven surface instead of a smooth one. Neither angle or size of the light source affects the diffuse reflection, but the distance from light to subject does matter: the closer the light source, the brighter the subject will seem in the finished image. Be aware that diffuse reflection has nothing to do with the light source quality; it is a quality of the subject, not the light.

When discussing the finished image, we can determine its reflected light values, the range of tones throughout the image. ***Specular highlights*** are pure highlights with no image detail recorded. They mirror the light source and usually exist within diffused highlights to add depth and brilliance to highlight. Specular highlights are usually created with a hard light. ***Diffused highlights*** are bright areas with image detail, which may contain specular highlights. Diffused highlights are usually created by a softer light. ***Shadow values*** are areas with little to no illumination.

THE TECHNOLOGY: IN CAMERA LIGHT METERING

Your camera automatically meters the reflected light for you with every press of the shutter button. When you are in Automatic, Aperture Priority, or Shutter Priority, the camera meters the light to determine the correct settings for proper exposure. When you are in Manual mode, the camera will still meter the light, and it will give you its recommendation on whether you are going to have correct exposure or if you will under- or overexpose the image. This in-camera light metering can change your overall readings dependant on how your camera is set to read the light.

There are several common *light metering modes*: evaluative or matrix (also called overall), center weighted, and center spot. *Evaluative* (also called *matrix* or *overall*) takes into consideration the entirety of the scene in front of you. If you are photographing a young girl in the shade with bright sunlight in the background, the camera will take into account both the shaded girl's face and the overly bright background and try to average the exposure between them. This can often lead to poor exposure on both the girl and the background; neither will be correctly exposed.

Center weighted light metering gives the most consideration to the area in the center of the frame, assuming you are placing the subject dead center in the middle of the image, then give lesser weight to the surrounding background. This differentiation can help you get better exposure on your subject, but, as you will learn in Chapter 6: *Composition & Visual Design*, we often do not want the subject to be dead center in the image. So this setting ends up being unnecessary if you compose your images without the subject dead center.

Spot metering is the third kind of light metering often offered by the camera, and this one is the best type of metering. Spot metering meters the light (and determines the exposure) off the center spot in the frame, allowing you to meter solely off of the subject and forget the background, making the exposure correct for the actual subject, regardless of where you place the subject in the frame. If you discover that your subject is not exactly on the center spot, simply compose the image so the spot is over the subject, press the shutter button half way down and hold it, then recompose the image to where you want it and press the shutter button down the rest of the way.

THE CHOICES:

Choose how the camera's light meter reads the scene in front of you. Overall / Evaluative works well for landscapes while Spot gives you the most control. Some cameras' subject modes now include backlight for difficult lighting situations.

THE ART - USING NATURAL LIGHT

THE JOURNEY OF THE SUN

As the day progresses, the quality and other properties of light also change. The number of particles in the atmosphere that the light must travel through changes as does the color and direction of the light. In the morning when the air is calm and clear of particles, the light can come through easily giving gorgeous sunrises. As the sun climbs in the sky, there is less and less atmosphere to pass through so the entire spectrum comes through producing the appearance of white light. The light is also more intense and brighter when it has less atmosphere to pass through. At the end of the day, when water, dust, pollution, and other particles saturate the air, only the longer wavelengths (warmer colors like oranges or reds) can get through.

After the sun sets and is no longer visible over the horizon, the light is sent up into the sky and can be reflected off clouds or particles in the air making beautiful, vibrant sunsets.

These and other changes dictate how we can use the light for the effects that we are trying to achieve. When the sun just peeks over the horizon at dawn, and it is at a very low angle to the ground, it can be used as sidelight, front light, or back light. As the sun climbs in the sky, as it gets closer to its peak, the angle of the light shining down on the ground changes, becoming top light. As the sun drops from its peak in the afternoon, it again becomes closer and closer to the ground, providing more side, front, or back light again.

These changes in sun angle mean you have different choices to make for your photography. The first choice you must make is whether you want to use front, top, back, or side lighting. Each has different strengths and weaknesses and is better used on some subjects than others. The second choice is what time of day will provide the best light for your subject.

The Light of Day

Light quality changes as the sun crosses the sky each day. Any time of day can be used for good photography time. However, there are good subjects and bad subjects for each type of light. The trick is to work with subjects that photograph well in whatever light you are in and save other subjects for a time when the light would flatter them. Photography is not only knowing what to photograph; it's also knowing what not to photograph.

Sunrise

There are several benefits to photographing at sunrise. For example, sunrise is good for water reflections because the wind has not started up yet and heat doesn't ripple the water. Also, animals are usually more active at dawn and the low angled light creates orange/yellow warm tones, which enhances textures and creates catch-light in the eyes which is great for wildlife imagery. Due to the low-angled light, you can choose from front, side, and back lighting depending on your creative desires. You can also catch things like frost, which lasts only a short time in the mornings but adds beauty to the photo.

Be aware that the timing for this light is very limited so you don't have time to find something interesting the morning of your shoot. Scout an area in advance to capture interesting foreground elements such as dramatic landforms, graphic trees or vegetation, or strong, graphic shapes. Also, be aware that the light will cause high contrast so expect silhouettes. Remember that the light changes quickly, so check of your exposure settings frequently or leave one setting (shutter or aperture) on automatic.

Early Morning / Late Afternoon

Early morning, when the sun is up to about 45 degrees high in the sky, usually provides side lighting, which is more attractive than top lighting. This time of day is good for close-ups and macros because there is more ambient light so you can use a smaller aperture for better depth of field but shorter shutters to decrease chance of movement. Due to the lower light intensity, though, you should bring a tripod as you may still need longer shutters than hand holding allows.

Sunrise

Early Morning

Midday

Late Afternoon

Sunset / Twilight

Overcast

Midday

Midday, when the sun is at its zenith, is usually not prime photography time. People and scenic photos do not make good subjects during this time of day as the harsh, overhead light creates deep shadows and over-blown highlights. The harsh light makes solid objects become silhouettes, transparent (slightly see-through) objects become translucent (very see-through).

However, there are several subjects that actually photograph best in this lighting. For example, canyon walls and architecture make good subjects because the overhead lighting makes textures pop (because it is sidelight to a vertical object). If you are going to photograph these subjects (especially buildings), you must take the position of the sun into consideration – is it more front or back light? If the subject is more backlit, the front of the building will be in shadow and partly silhouetted. If the subject is more front lit, the front of the building will be properly lit and will show detail in the texture.

The harsh overhead light can also be used when photographing into water. Sunbeams straight down into water can make water more see-thru, better to see corals, fish, etc. Midday can also be used for resting in preparation for later shoots, scouting areas to visit when the light is better, planning your evening session, general sightseeing, etc.

> **Technical Tip:**
> Remember, when working at midday, the subject should be brighter in tone than the background is.

Sunset

Sunset is a good photography time because you have the rich, warm light of a low angled sun, and you have more time to watch the light change and choose a good camera position. Sunset dramatizes macro photos. However, sunset's waning light usually requires longer shutter speeds (and a tripod to steady the camera), so if you cannot control your camera settings, these shots can be hit or miss. About 20-30 minutes after sunset is also good lighting with interesting coloring.

> **Creative Tip:**
> Stormy weather, with large rolling clouds, looks best when the sunlight breaks through briefly so be prepared (compose your picture early with proper aperture and shutter setting) so that when the sun peeks out, you can just push the shutter button.

Twilight

Twilight, the 20-30 minutes after the sun has dropped below the horizon line has dramatic bluish-purple skies, especially in winter. Twilight shooting is very pretty but very time consuming as the waning light requires long exposures. Luckily, there is large latitude (up to 1 or 2 stops) for mistake. Photographing buildings with artificial light changes the color of the final photo and can produce a dreamy, supernatural effect on ordinary or even boring architecture.

Overcast

Overcast skies produce a soft, even, diffuse light, which brings out color saturation. Water subjects, macro photography, and portraiture are good subjects for these conditions. These conditions are wonderful for richly detailed artwork, which needs diffused light. If photographing nature or scenics, leave the dull sky out, though, as it will detract from the photo.

Be aware, overcast skies can play tricks on your camera. Most cloudy days produce a bluish cast to photos because of the cooler light

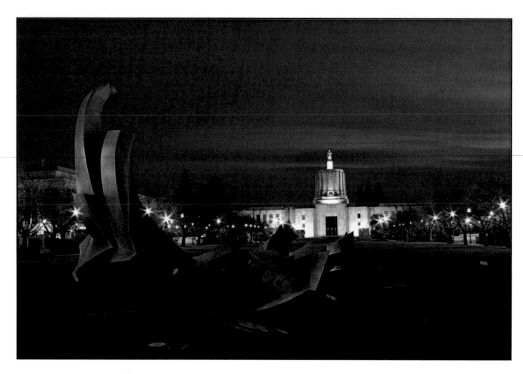

Photographing the **twilight** sky takes a long shutter speed and a tripod.

temperature of overcast days than sunny days. In digital cameras, this can be corrected both in-camera with your white balance and in digital editing post capture.

You should also consider overexposing by up to 1 stop to brighten pictures so they are not drab, especially in low, dense fog. In fog, the water particles will reflect light back to the lens so the in-camera meter will be fooled into thinking an underexposed photo is properly exposed. So, if your images are not as bright as you would like, remember your Exposure Compensation.

THE CHOICE: MODIFYING THE LIGHT

A good photographer learns to recognize types and properties of light and knows how to use the light that is available. However, sometimes the light could use a little modification to enhance it. There are several ways to modify light including polarizing the light, using diffusers or reflectors, and using a fill flash.

POLARIZING THE LIGHT

Polarized light simply refers to light in which all the waves are moving in the same direction. Sunlight is naturally unpolarized; the waves move in many directions. When unpolarized light strikes a non-metallic subject, such as water, some of that light gets lost in the water while the rest is reflected back to the camera or our eyes. This reflection of light allows us to see reflections in the water. When the water ripples, the light is again scattered and we lose the reflection.

A *circular polarizing filter* removes wavelengths traveling in one direction allowing the light traveling in other directions through. You can adjust a polarizing filter to remove reflections and glare from wet surfaces. This allows the photographer to see into water (removing the reflective glare on the water's surface), into store windows (removing reflections from the glass), or to remove glare from leaves and other objects to bring out their full color (removing the light reflecting off the moisture in the leaf or off the damp surface of your subject).

Using Diffusers and Reflectors

Remember that when light travels in straight waves with nothing between the light source and the subject, the harsh light records high tonal contrast (bright highlights and deep shadows that may show no detail depending on how high the contrast gets). *Diffuse light* is light that has gone through another substance that scatters the light waves and decreases the tonal contrast. A *diffuser* is anything that can scatter the light waves to give you that nice even light with lower tonal contrast. The cloud cover on an overcast day works as a natural diffuser. You can purchase man-made diffusers in multiple sizes that you can carry with you that will help with smaller subjects (flowers or details of the landscape or even some portraits). You can even make your own diffuser with a white sheet for slightly larger subjects (such as full length portraits) but it will do nothing to help diffuse the light on the distant mountain.

Reflectors, on the other hand, help you direct the light where you want it to go. If you need a little boost of light on your subject, you can use a reflector to direct some ambient light waves towards your subject, increasing the illumination on the subject, yet leaving the background darker. This works really well for portraits when the eyes of the face are shaded by the eyebrows and other facial bones, giving the subject raccoon eyes (deep shadows in the eyes). Reflectors can also help you direct light onto a stationary nature subject. I say stationary because the reflector requires specific adjustments to direct it in the correct direction and live subjects can easily move or run off before you are set up. Nature may also provide its own reflectors in a white wall or a large patch of snow.

Fill Flash

Fill flash refers to using your flash to add a small boost of light to the subject, filling in the shadows a little. Fill flash is easy to overdo, though, so be careful how and when you use it. Not only can you over-flash the subject, which bleaches the color from the image and leaves the ever-so-obvious deep shadow behind the subject, but if you use the same fill flash set-up with every image, then all your images will have the same look and feel to them, creating a dull portfolio.

Many cameras and external flash units have controls that allow you to reduce the amount of flash output. When using fill flash, you should try to just add enough light to fill the shadows but not so much to truly change the feeling of the ambient light. To do this, set your flash to -1 or -2 stops using *Flash Compenstaion* so the ambient light of the scene remains the main light source.

If you find that you use fill flash regularly, you can purchase accessories that allow you to move the flash around in order to get different angles of light so your portfolio remains varied and interesting. There are numerous flash attachments that can attach to the camera to hold an on-camera flash to one side or the other, higher or lower than the camera. You can also get a flash that has a remote sensor so you can set the flash up in a different location than the camera is sitting, allowing for an even greater variety of lighting angles.

If at all possible, try to avoid the on-camera flash that sits directly above the lens. First of all, this produces a harsh frontal light that steals the dimensions and textures from your subject. Secondly, when photographing people, a frontal flash can produce "red eye" which is a reflection

of the light bouncing off the red blood vessels of retina on the back of the eye and traveling straight back to the camera. Moving the flash even slightly off that direct path to and from the subject will give depth and dimension to your subject and reduce the risk of red eye.

LOW LIGHT PHOTOGRAPHY

I've heard it said that photography is easy…when you have ideal conditions and great lighting. All other times, you have to work at it. Photographing in low light brings its own set of challenges, but with those challenges comes a new set of rewards as well. With a little time and thought, you can come home with wonderful low-light images.

COMPENSATING FOR LOW LIGHT SCENARIOS

We discussed earlier that when you are faced with lower ambient light than is ideal, you have a few options. First, bring along a tripod and leave the shutter open for longer periods of time, allowing more light to come in and exposure to be achieved even at small apertures which will give deep DOF while retaining a lower ISO and lower noise levels. A second option is to use a flash or other light to add more light onto the scene. Third, you can increase the ISO to increase the camera's light sensitivity to be able to keep the shutter at handheld speeds (1/60 or faster).

TWILIGHT

What are some common low light scenarios? Twilight, just after the sun has set, while the light from the sun still illuminates the sky, is the most common low light time to photograph in. Twilight lasts until all color leaves the sky, usually 30-45

Photographing **indoors** requires a tripod and longer shutter speeds to keep noise levels low.

minutes (but can be longer in summer months). Artificial lights get subtly brighter just after twilight and the contrast between a building face and the sky lessens so we can get good exposure on both.

Photographing at twilight can give you some great photographic opportunities. Cityscapes full of buildings with lights twinkling with a deep purple sky overhead or colored reflections from traffic lights or business lights on wet streets, blasts of colorful fireworks, artificial light on architecture, head light or star trails, the possibilities are endless.

PHOTOGRAPHING INDOORS

When photographing interiors, properly exposed photographs are more difficult because there is usually a mix of shaded natural light and artificial light. This creates a lower intensity of light that needs longer shutter speeds to achieve proper exposure. Longer shutter speeds usually require that you use a tripod as well to steady the camera. Unfortunately, due to the limited flash capacity of most on-camera flashes, flash is usually useless in a large room.

Dull, inside lighting with mixed bright, outside light coming through a window can also create exposure problems. The bright light from outside directly next to the deeply shaded inner window frame causes a very large difference in the light from highlights to shadows. Try composing without the window in the frame (so the ratio of highlights to shadows is less extreme.) If left to its own devices, the camera will try to average the exposure between the highlights and the shadows, which (since there is such a strong difference between them) will not properly expose for either; it will over blow the highlights and keep the shadows too dark. The ratio of highlight to shadow may make you choose which you most want to expose correctly – outside the window, using the window structure as a blackened frame for the outdoors, or inside the room, leaving the overly bright window with no detail.

CONCLUSION

Light is the basis of any and all photography so learning the properties and physics of light will help you create beautiful photographs. Light travels in waves from the light source (often the sun) to the subject, interacts with the subject, and then gets reflected to you and your camera. Understanding these relationships will allow you to determine how the camera will "see" the light and how it will record the light on your image. Even if an image has great composition, a beautiful subject, and captures a great moment, if the light doesn't work with the subject, the image will suffer even to the point of being unusable. But all light is useful, so you just have to know when to use and/or modify the type of light you have available to you.

5 Color Theory & Usage

"The chief function of color should be to serve expression." - Henri Matisse

WHY STUDY COLOR?

The ability to perceive color is a rarity among animals. Few animals, humans among them, are believed to have the ability to distinguish color instead of just shades of black, grays, and white. Color pervades throughout our cultures, even through our language. We use terms like, "green with envy", "seeing red", "true blue", "white as a ghost," or "yellow bellied coward."

Color can influence and interact with the other physical senses. Even the blind can experience color; given varying sheets of colored papers, blind persons can commonly sense them as different from each other. Some people sense color when they hear music – a form of *synthesia*, experiencing two different types of sensory perceptions in one stimulus. *Chromotherapy* is the treatment of medical disorders with colored light. While this may seem more like mystical blathering, physicians place premature babies with jaundice under blue light to help them recover.

In interior design, color can affect your mood. Notre Dame coach Knute Rockne painted the lockers of his home team red to stimulate and energize them while he painted the opposing teams lockers blue green to relax and calm them. Green walls in a hotel or cabin can also help travelers relax and adjust to the new environment.

Beyond the first 6 hues and their names there is little agreement about color. It is a mystery that fascinates us. While no one theory can explain the varying phenomenon that we can associate with color, let's discuss some of the more common ideas and how they relate to photography.

THE SCIENCE: PERCEPTIONS OF COLOR

Nicholas Ogden Rood said "Color is but a sensation and has no existence outside of the nervous system of living beings." Color perception is a response to a visual stimulus (light), a sensation that activates the light receptors. This begins the process of perception. ***Perception*** is the attempt to understand and make sense of the stimuli received by the brain. The brain interprets all visual stimuli. Our perception varies person to person so much that color is sometimes considered to be more a perceptual sensation than a physical property of the subject (remember, reality does not exist; it is your perceptions of the world that determine your reality).

REACTIONS TO COLOR

Our responses to color can be based on a variety of different factors from physiology, to psychology, to cultural or personal factors. Physiologically, color affects your bodily states. Red raises skin temperature, blood pressure, respiration, while blue lowers them all. Color can also affect the psyche and mood. The US Navy found that after placing aggressive and violent offenders in a pink colored brig (their version of a jail) the sailors would become withdrawn and easier to control in the short run but more aggressive in the long run. This can also work in reverse. Mood can effect your perception of color.

Depression makes colors seem dimmer and duller.

Your food and eating habits can be affected by color. Blue plates or lighting will make food unappealing (dieters – here's a trick to remember next diet time) while pink makes things taste sweeter (that's the reason that bakeries love pink frosting). Red, yellow, and orange stimulate the appetite and increase the speed in which you eat. Fast food restaurants that want you to come in, order a lot, eat quickly, then leave quickly so the next customer can come in tend to be painted in these bright reds, yellows, and oranges (think McDonald's). Higher end restaurants that want you to stay and relax over a drink or coffee (which enhances their profit) tend to be painted in blues or greens or violets, which calm and relax patrons and encourage lingering.

Interestingly, socioeconomic status can also affect your perception and enjoyment of colors (a good thing to keep in mind if you are wanting to sell your work – who your target market is and what they like to look at). People of higher economic status tend to like darker, more saturated and complex tones while people of lower economic status tend to prefer simple, bright, pure hues.

Cultural and geographic changes also affect our perception of color. Whereas, here in America, we use white for weddings and black for mourning, in India, they wear black for weddings and white for funerals. China also uses white for mourning. In Ancient Egypt, black was used to symbolize rebirth when placed on the statues of Osiris. On the other hand, in the West Indies, death is a celebration of moving on to a better place and is shown in bright colors.

As the life cycle changes, so does our appreciation for color. As children we enjoy color for the sheer color of it. As adolescents, those who are sensation seeking will gravitate towards reds while a more reserved child may prefer blues. The elderly tend to like lighter colors over darker ones, but not yellow, which is the least liked color among elderly. Extroverts prefer warm hues while introverts tend to like cooler hues.

Even global location can effect our response to color. Strongly lit countries seem to prefer warm, bright colors while less bright countries prefer cooler, less saturated colors. On the whole, color affects our day-to-day lives and influences our emotional states and moods. As photographers color is a powerful tool to use to evoke the viewer's emotions. Check out some of the common interpretations and meanings of the main colors in *OBSERVE: COLORS THAT SPEAK AND WHAT THEY SAY.*

THE SCIENCE: LIGHT & COLOR

Light is an energy form that travels in waves through the atmosphere. These waves are measured in *wavelengths*, which is the distance between the two crests in the energy wave, denoted in *nanometers* (nm = one billionth of a meter); changes in the wavelength result in a change in the type of light, from gamma rays to television rays.

We can only visually perceive (without mechanical assistance) a small portion of this *Electromagnetic spectrum*, from about 400nm to about 700nm.

The longest visible wavelengths are seen as the color red (700nm) while the shortest ones are seen as the color blue or violet (400nm). The camera can often pick up energy rays that the human eye cannot see. Therefore, some photographers consistently keep a UV filter on the front of the lens, to block the UV rays that you will not see but that the camera will detect.

As light travels, it moves in predictable patterns. It interacts with matter in predictable ways. Some matter, like glass, can refract, or bend the light wave, but otherwise allow light to pass through. Other matter absorbs the light completely. Still other matter absorbs some of the light while reflecting other portions of the light.

Photographically, there are two different beams of light that we care about – the *incident beam* is the light that travels from the light source to the subject while the *reflected beam* is the one that bounces off the subject to travel to the eye or the camera. Both beams are important when discussing photography and color as both beams can have different colors and will interact with the eye and the camera in different ways.

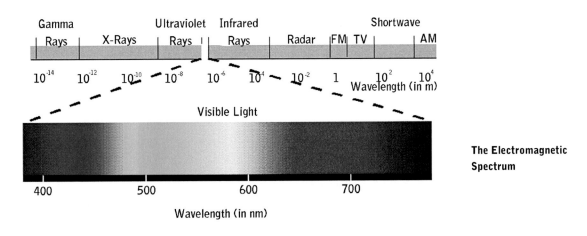

The Electromagnetic Spectrum

Observe: Colors Speak & What They Say

"Colors, like features, follow the changes of the emotions." —Pablo Picasso

Color can have personal meanings to different peoples and across cultural boundaries. The descriptions below discuss some of the common interpretations of various colors, but these are based on the average American person and are certainly not absolutes. As colors will have an effect on how the viewer interprets your image, it is important to use them to accurately speak your message.

Colors speak all manner of emotions and moods. As a photographer, use colors not only to grab and hold the attention of the viewer, but also to influence and interact with the viewer's emotions.

Red

"Painters use red like spice." – Derek Jarman

Red stimulates. Red energizes. It grabs attention. Red shows heat, passion, anger, or excitement. It is domineering. Red increases enthusiasm and stimulates the respiratory and circulatory systems. It encourages action and confidence. When even a small amount of red is visible, the eye will see it first.

Sayings about Red
Caught red handed – clearly guilty
Red in the face - embarrassed
Seeing red – being angry
Red flag – a warning
Red letter day – a memorable event
Red tape – formal, governmental processes
In the red – an economic loss
Red carpet treatment – privileged treatment for important persons

Pink

"Pink is the color of romance and a friend tells me that the girl with the pink dress at the party is the one who is selected for each dance."
-Alfred Carl Hottes

Pink is fun, youthful, lighthearted, and happy. It can be sensual and full of passion without being aggressive. Pink is soft, feminine, and gentle in nature. However, in one European country, pink is used for the team color of a popular soccer team – so this feminine interpretation is a more American one.

Bright pinks have similar effects on the body as reds, raising respiration, blood pressure, heartbeat, and energy levels. Pink encourages action and confidence. Recently, pink has become associated with the fight against breast cancer.

Pink can also have a tranquilizing effect, especially on men. Being in a pink painted room can reduce aggression and calm hostilities. Interestingly, some studies have shown that male weight lifters seem to lose strength when training in a pink room while female weight lifters seem to gain strength.

Sayings about Pink
Tickled pink – to be happy
In the pink – in good health
A pink elephant – hallucinations during intoxication
Pink slip – notice of termination from work
Pink collar – class of jobs filled only by women

Orange

"Orange is red brought nearer to humanity by yellow."
–Wassily Kandinsky

Orange usually invokes strong reactions. Whether you love orange or hate orange, you probably aren't neutral about it. Orange implies heat or passion. It can also show fun or frivolity and can energize the image with warmth.

It encourages activity and socialization. Orange also stimulates the appetite. It is also the color representing the US Army Signal Corps. In Christianity, however, orange is often shown to symbolize gluttony, one of the seven deadly sins.

Sayings about Orange
Carrot top - having orange-red hair
the Big Orange - Nickname for Los Angeles County
Orange Bowl - College playoff game
Clockwork Orange - a metaphor for a living being transformed into an automaton

Yellow

Yellow is the first hue our eyes will perceive; it's warm and satisfying, lively and stimulating. Yellow can also imply heat. Yellow shines with happiness, enlightenment, and optimism. It stimulates not only individual mental processes but also the nervous system as a whole. Yellow has also been known to help spark creative thought and encourage communication.

Several different cultures have viewed yellow differently. The Chinese Ming dynasty and the Qing dynasty both used yellow predominately. The Aztecs used yellow to represent "food." Other cultures see yellow as a more negative color. The Greeks have seen it as "sadness" and the French as "jealousy." Christianity uses yellow to symbolize "greed," another of the seven deadly sins. A yellow flag indicates caution here in America, and when used in medical terms, it means a medical quarantine is in effect. In football, a yellow flag represents a penalty.

Sayings about Yellow
Yellow bellied – cowardly
Yellow fever – a disease with fever and jaundice
Yellow jack – a flag flown on a vessel under quarantine
Yellowdog contract – contract which denies a person the right to join a worker's union
Yellow journalism – newspaper articles that are sensationalized to sell more copies
Yellow Brick Road – a fantasy road leading to a magical place in a dream, made popular by The Wizard of Oz by L Frank Baum.

Green

Green is common throughout the natural world, so we see it as peaceful (light yellow green feels the most peaceful) and restful. It represents nature, rebirth, renewal, or freedom. The God of Fertility of Celtic lore is often seen in green. Green soothes and helps relieve depression, anxiety, or nervousness and promotes mental and physical relaxation. These days, "going green" is associated with adopting ecologically friendly practices.

Sayings about Green
Get the green light – get approval to move ahead in a project
Green thumb – the ability to make plants grow
Greenback – legal tender note issued by the US Government
Greener pastures – something newer or better than the present
Green with envy – jealous
Greenhorn – a novice
Green around the gills; turn green– looking sick, nauseous, pale

Blue

"Blue color is everlastingly appointed by the deity to be a source of delight." —John Ruskin

Blue is the all time, all around favorite color for both men and women. It implies coolness, mist, shadow, peace, calm, or contemplation. Here in America we associate it with masculinity. Blue calms and soothes. It makes the environment seem physically cooler, as in lower in temperature.

In 431 AD, when the church began associating colors with saints, blue was linked with the Virgin Mary so it has become a symbol for her piety, truth, and goodness. Navy blue is still considered trustworthy, honest, and confident. What lawyer or politician would go without a navy blue suit? Denim fondly reminds us of the Wild West and the era of the cowboy. The blue collared man is the hard working man, the backbone of America. Blue is calm waters and vast skies. Bright blue shows drama and exhilaration. Powder blue has become associated with cleanliness.

Hint, you don't want to wear blue while camping though, as mosquitoes can see the color blue twice as easily than any other color.

Sayings about Blue
True blue – loyal or faithful
Blue ribbon – first place, the best of show, of highest quality
Blue blood – an aristocrat
Blue law – laws about morality issues
Blue comedy – jokes about socially taboo subjects
Blue plate special – specially priced meal at a restaurant
Bluestocking – woman with scholarly interests
Feeling blue – sad or unhappy

Purple

"Mauve? Mauve is just pink trying to be purple." —James Abbot McNeill Whistler

Purple combines red's excitement with blue's cool tones. Deep purple traditionally implies royalty, richness, or flamboyance. Lighter purple can indicate coolness, mist, mystery, and mysticism. It is often enjoyed by creative or eccentric people. It is also the favorite color of adolescent girls. It uplifts the mood, calms the mind, and encourages spirituality.

In Japan, purple symbolizes wealth and position. Purple was the color of several royals including the Caesars and some English royalty. Egyptians see purple as faithful and virtuous. However, Christianity uses purple to symbolize the sin of "pride" so it does have some negative connotations with it.

Sayings about Purple
Purple prose – elaborately written verse
Lay it out in lavender – cool relaxed, in control
Purple people eater – the subject of a song in the 1950s
Born to the purple – born to royalty or nobility
Purple heart – medal awarded to US soldiers wounded in battle
Purple haze – the title of a Jimi Hendrix song, also the name of one strain of marijuana, used to indicate intoxication

Brown

"Chocolate brown is about the friendliest, least threatening, color one can choose to wear." —Diantha Harris

Brown represents nature, trees, and wood. It is organic. It is stability, reliability, and approachability. Brown is warm and inviting. It is a neutral color, useful for balancing strong colors.

Sayings about Brown
Brown sugar – partially refined sugar
Brown bagging – to bring a homemade brown bagged lunch to work
Brown out – partial loss of electrical power
Brownstone – building made from darkly colored sandstone
In a brown study – someone deep in thought

Gray

"The fundamental grey which differentiates the masters, expresses them and is the soul of all color." —Odilon Redon

Gray is intellectual and wise. Your "gray matter" refers to your brain and intellect. It is seen as classic and sleek, dignified and authoritative. Being halfway between white and black, gray is compromise. Gray is color neutral; it enhances and intensifies any color it surrounds. Interestingly, the human eye can perceive upwards of about 500 different shades of gray.

Sayings about Gray
Gray market – buying or selling products priced below regulated prices
Gray mood – unhappy
Gray area – unclear area (often associated with legal terms)

Black

"People can have the Model T in any color — so long as it's black." –Henry Ford

Black shows elegance and class; it is authority and power. Black can overwhelm; when surrounded by black, other colors will seem to shrink.

It represents lack of color, emptiness, or "the void." It can show evil, fear, or death. Here in America, we wear black for mourning. The Aztecs saw black as the color of war due to the black obsidian blades they used. A black cat crossing your path is considered bad luck in many cultures.

Black is a common in clothing choice. It is useful for contrasting against colors. Black also makes the wearer look thinner and slimmer. It makes one feel inconspicuous and able to fade into the background.

Sayings about Black
Black coffee – coffee without milk
Black belt – highest belt awarded in martial systems
Blackball – voting against someone in secret
Black mail – to demand payment or action by way of threat
Black sheep – a bad character in an otherwise respectable group
Black comedy – creating a comedy out of a tragic event or situation
Black ____day (ex.: Black Friday or Black Tuesday) – a bad day, usually symbolizing a tragic event

White

"White is not a mere absence of color; it is a shining and affirmative thing, as fierce as red, as definite as black." –Gilbert Keith Chesterton

White symbolizes purity, cleanliness, spirituality, or innocence. Brides wear white (here in America) symbolizing their purity before the marriage. Doctors wear white coats to show cleanliness. White aids in mental clarity and encourages the clearing of clutter. White visually opens up a living space. White allows for new beginnings and a white flag symbolizes a truce.

Photographically, white is great for establishing clarity and contrast. When white surrounds any other color, that second color will seem to expand and grow within the white. It will also help to intensify other colors.

Sayings about White
White picket fence – a symbol of the American dream home and a happy family
White Christmas – snow on Christmas day
White elephant – a possession that no longer holds value for the owner
White flag – signal of surrender
White hot – extreme intensity
White lie – harmless lie usually told out of politeness
White feather – symbol of cowardice

The Primary Colors of Light. The primary colors of light, red-orange, green, and blue-violet, mix together to form the secondary colors yellow, cyan, and magenta. When combined all together, the light turns to white light. This is called **additive light.**

THE COLOR OF LIGHT (THE INCIDENT BEAM)

In the 17th century, Sir Isaac Newton sent light through a prism and separated that light into 7 basic colors: red, orange, yellow, green, blue, indigo, and violet. Many color theorists agree that these 7 (or 6 if you combine blue and indigo which is hard for the human eye to distinguish) colors are the basis for working with all color. You can see these colors in a rainbow. Let's expand on this basic color theory.

There are three *primary colors of light*, light that cannot be broken down into any other colors: *red-orange, blue-violet,* and *green*. When discussing light, the more colors of light you add in, the "whiter" it becomes. When you mix two primary colors of light, the resulting light is brighter (red-orange and green make yellow, green and blue-violet make cyan, and blue-violet and red-orange make magenta). In fact, if you mixed the three primary colors of light, red-orange, green, and blue-violet, in equal amounts you would produce a white light.

Because of this "mix to white" effect, we call this *additive color*. It adds together to pure white. You can think of this as the color that is added to the subject from the light source.

COLOR TEMPERATURE

Color temperature is the common way of describing the main color changes that incident light goes through. Daylight varies in color throughout the day and natural light differs in color from artificial light. These color designations lie on the Kelvin scale and are referred to as color temperature.

The *Kelvin scale* is based on the work of a physicist named Kelvin who heated a "blackbody radiator" (a black piece of metal that can absorb all radiation striking it) and recorded the color the radiator turned as it was being heated. This experiment can be replicated today. As the radiator is heated, first you will see a dull red glow, then orange, yellow, and white heat. Finally, the substance will turn blue.

While light itself does not heat or cool, it does turn colors that match those on the color temperature scale. As the day progresses, as the light source changes, the light changes in color temperature as well.

The closer the sun is to the horizon, at dawn or dusk, the more yellow or red the color temperature is because the light has more atmosphere to travel through and the shorter blue wavelengths get lost in the shuffle. Morning light is yellowish, more so at dawn and then successively less until noon. The sun, at its zenith, on a clear day is referred to as "white light." Our eyes evolved under the midday sun, which our eyes grew to see as "neutral." Cloud cover changes the light to a bluer light as the longer red and yellow wavelengths are absorbed into the water particles in the air. The more clouds are present, the more blue the light. Deep shade also looks bluer than regular sunlight.

The different types of light bring out the different qualities of color. Bright, harsher light shows rich, accurate color while diffuse light through haze, mist, and fog shows subtle, muted, almost pastel colors.

Why does this matter? Your eyes will automatically adjust for these light subtleties, but in photography, the digital sensor will record what is actually there. Your eyes will view a white shirt under Tungsten light, daylight, and overcast light as a continually white shirt, an effect called *color constancy,* but the camera will record a yellow shirt (Tungsten), a white shirt (daylight), and a blue shirt (overcast). You need to be aware of these color shifts so that you can adjust for them so your final picture has the effect that you are looking for. In digital cameras we use White Balance to correct for these color shifts.

White Balance

When we dealt with film, photographers would have to recognize which type of light was present and then correct for it with colored filters. These days, with digital we use the ***White Balance (WB)*** feature to correct for lighting color changes. The WB feature uses symbols to represent the main lighting choices: sunlight, cloudy, shade, tungsten, incandescent, fluorescent, flash, and custom. Simply set the WB setting to the type of light the subject is in (if you are in the sun, but the subject is in the shade, set the WB to shade). For those who have ever lived in the Pacific Northwest, you know that there are differing levels of "cloudy" and one setting cannot cover them all. The WB settings are generic settings. If you wish to get more specific, you can experiment with the Custom WB (check your manual for the exact directions on how to use your specific camera).

The color of incident light can change dramatically throughout the day, which affects your final image. To see the true colors of the subject, you must account and correct for these color-casts from the light source.

Color of Matter (the Reflected Beam)

Remember that when dealing with the incident light beam, we were talking about additive light; the more light waves you got, the closer to white the light was. When dealing with the colors of matter, we are talking more about subtractive color. When mixing pigments to create color, the more you add, the closer to black you get. This "mix to black" is called ***subtractive color***. When the light strikes the subject, the pigment / color of the subject reflects some light and absorbs some light. Subtractive color is the left over color

The Primary Colors of Matter. The primary colors of matter, red, yellow, and blue, combine to make the secondary colors, orange, green, and purple. Theoretically, when you mix all the primaries together, you would make black. Combining the pigments increases the amount of light absorption the pigment has, therefore subtracting more light from the subject, leaving less light to reflect back to the viewer. This is called **subtractive light.**

Tints and Tones. A purple hue with varying tints (lighter, to the left) and tones (darker to the right) of the hue.

after the subject "subtracts" and absorbs all the wavelengths the pigment can. The more pigment you apply, the more it subtracts the reflected light by absorbing it.

In 1703, J.C. Le Blon discerned 3 *primary colors of matter*; colors that could not be broken down any further, but could, in theory, combine indefinably to produce any other hue and when mixed in even amounts would make pure black (in reality it does not quite work that way, mixing all hues of pigments together gives you a murky grayish brown color). These colors, *red, yellow, and blue,* are the basis for the *color wheel*, a circular chart that organizes colors.

When discussing color, we talk about ideas such as hue, value, and saturation. *Hue* is the specific color you are using, the red or blue-green. Each hue can have multiple *tonal values*, the overall brightness or darkness of the color, changed by adding white or black to the hue. *Tints* are the lighter shades of the hue (mix purple with varying amounts of white) while *tones* are the darker shades of the tones (mix purple with varying amounts of black).

Saturation is the intensity or the purity of the hue. Color saturation is adjustable; by adding the hue's complementary color, the color opposite on the color wheel, the original hue reduces saturation and turns to a neutral gray. A desaturated color is a shade of gray.

THE SCIENCE – COLOR THEORY

The Color Wheel

The *color wheel* has become the common way to organize colors for artistic use. The various hues are aligned in a circular shape, symbolizing the never-ending and ever-adapting nature of color. While color wheels can be constructed with as few as 6 colors, they are more commonly found with 12 and can go up to 48. Remember Le Blon's primary colors of matter: red, yellow, and blue? These are the basis for the color wheel. Primary colors combine to make secondary colors: red and yellow make orange, yellow and blue make green, and blue and red make violet. When you combine a primary color with a secondary color it creates a tertiary color: yellow-green or red-violet. The color wheel can be separated into cool (green, blue, violet) and warm (red, orange, yellow) hues.

The Reflectivity of Color

Remember the concept of reflectivity and 18 percent gray? Different subjects reflect light at different levels while the camera will always

The Color Wheel organizes the colors in the spectrum on a never-ending circle. Colors that sit across from each other complement each other. When combined in equal amounts, they make neutral gray, hence the gray circle in the center.

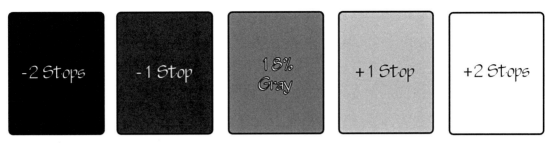

18 percent Gray. The camera is programmed to make 18 percent gray when calculating exposure, so make sure you either meter off something that is 18 percent gray or adjust the exposure to match the scene.

The Reflectivity of Color

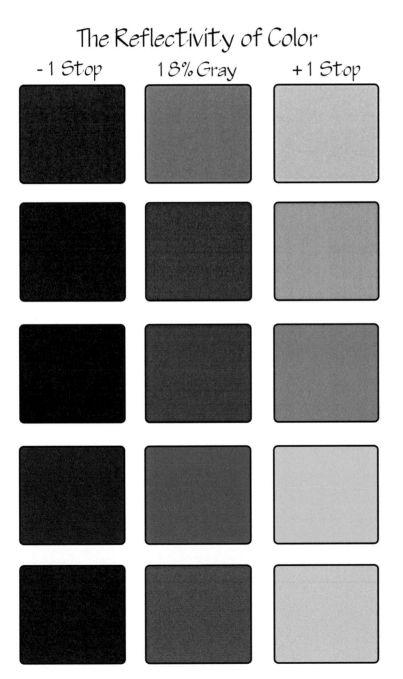

The Reflectivity of Color. Colors reflect back at different values based on the light source. Keep this in mind when figuring your exposure, especially when the camera has any control over the final exposure (the camera is in any exposure setting other than manual), as you may have to adjust exposure to ensure true color rendition.

Monochromatic Scale Varying the tints and tones produces contrast within a single color.

try to create a tonal value of 18 percent gray, exact mid-toned. In order to create accurate exposure, you must either meter the camera off of something that is reflecting at 18 percent gray or make manual adjustments to the camera to compensate.

This concept of reflectivity applies to colors as well. Colors change depending on the intensity of the light that is hitting them and being reflected off of them. Colors can have values that are equal to the achromatic range (shades of gray). While white and black have no equivalent, all other shades of gray do have equivalent color tones.

For example, we have already discussed that 18 percent gray is directly between black and white and that black reflects 2 stops of light less than 18 percent gray while white reflects 2 stops of light higher than 18 percent gray. Other colors do the same thing. Grass green reflects back at the same values as 18 percent gray while deep forest green reflects 1 stop lower (darker or less intense) and mint green reflects 1 stop higher (brighter or more intense). So when you are looking at the scene in front of you, remember to try to find colors that match the tone of 18 percent gray to meter off of so your camera properly records your color values.

COLOR SCHEMES - USING COLOR

An **achromatic scale**, which comes from the Greek "a"- meaning without and "-chroma," meaning color, deals with shades of gray, tones purely dark to light, void of color. Technically, white and black are not considered hues. White is the reflection of all color while black is the absorption of all color, but they are not individual colors themselves. They are considered neutrals along with gray.

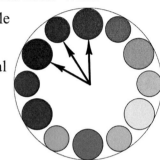

Analogous Harmony.

With the addition of a single color we can create a **monochromatic scale**, mono- meaning "one." To increase the sense of contrast within a monochromatic scale, we rely on varying the value (tints and tones) and saturation of the hue.

Analogous harmony refers to using colors that are next to each other on the color wheel. This produces the least contrast and the colors blend easily into one another. We also call this **color harmony**. It produces pleasant, soothing, and relaxing images.

Colors that sit across from each other on the color wheel are called complements. Two complements mix to a neutral, almost gray, color. They complement each other.

Achromatic Scale. Differentiating values between black and white.

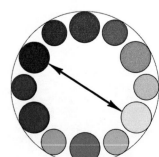

Complements creating
Complementary Contrast.

Red-Green complements

Orange-Blue complements

Yellow-Purple complements

Color complements produce the most color contrast. If the two colors are of equal value and saturation, they will agitate the color receptors in your eye to such a degree that the colors will seem to vibrate, an effect known as ***complementary contrast*** or ***color contrast***. Again, I want to point out that this effect is a result of the reaction in the eye, not of the color itself (our perception creates the reality).

Color harmony and color contrast are the most common ways of dealing with color in a photographic sense. There are other combinations, but they are harder to find naturally. A ***Triad*** happens when 3 colors are used that are equidistant from each other on the color wheel. ***Split complementary contrast*** refers to one color (ex.: yellow) with the two colors outside its

complement (the complement to yellow is violet so use red-violet and blue-violet). This reduces the contrast a bit from full color contrast, but still produces a visually stunning effect. ***Double complementary contrast*** refers to 2 adjacent hues and their complements (blue-green and blue with red-orange and orange).

COLOR INTERACTIONS

Edwin Land developed the ***Retinex theory***, which says that every color will look just a little bit different when placed against different background colors. This theory has become known as ***simultaneous contrast***.

Not only does this effect happen when one color surrounds another, but also when one color is surrounded by black or white. Being surrounded by black will seem to compress or hold in the color while being surrounded by white will make the color seem to expand and swell into the white area.

Triad.

Split Complements.

Double Split Complements.

Observe how the purple seems to swell into the white while it is compressed by the black.

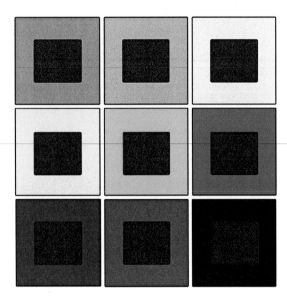

Green fills the frame in this image. The characteristics of green, peacefulness, relaxation, and calmness pervade through this image.

Simultaneous Contrast. Observe how this dark red changes just a bit when against different colors. Does it look different to you when seeing the red on purple or the red on yellow?

THE CHOICES - USING COLOR IN THE ENVIRONMENT

How can we use some of this knowledge to enhance our photographic compositions? Well, when we are working in the studio, where we have complete control over every aspect of the final image, this should be easy to figure; choose the colors that best speak what you want to say. Warm, vibrant colors or contrasts are energizing and show happiness and liveliness. Cooler, darker tones and harmonies are more relaxing and peaceful. In the field, this can be a bit more difficult as we have less control over the colors that are present.

One way we can use color is to help control the sense of depth in the image. Warm, saturated, bright colors seem to visually advance and come closer to the viewer while cool, darker, dull colors visually recede into the background. Putting warm vibrant colors in the foreground and cooler, duller colors in the background will enhance the visual illusion of depth. Conversely, putting warm colors in the background and cool colors in front will make the image seem overly shallow, often an unwanted effect.

Blue sits in between green and purple on the color wheel, giving this image a harmonious feel, a calming feel.

There are several ways to use color to make a statement. You can fill the frame with one color – use a monochromatic scale. If you choose to do this, you must compose with strong design elements and an interesting subject. You can also use harsh shadows or textural side-lighting to enhance contrast by

increasing the differences in tones and tints. When you use this form of speaking with color, the image screams whatever that particular hue says (see **OBSERVE: COLORS THAT SPEAK AND WHAT THEY SAY**).

You can also use a single colorful element as an accent in an otherwise muted or neutral environment. When using two colors, creating color harmony gives subtle impact and is soothing while using color contrast energizes the image. Muted color (soft lighting, desaturated color, low contrast) is common in nature and helps create color harmony. Muted color comes out when the days are overcast. If you are photographing on a sunny day, you can use a diffuser to soften the light and mute the colors. Vibrant colors help create color contrast and are shown best in bright light.

Another way to use color is to put roughly equal amounts of several colors, using either color harmony or color contrast. You can try bold and shocking, or soothing and peaceful or anything in between.

You can also use one over arching color (like a field of flowers), which makes the image hint at what that particular hue says (see **OBSERVE: COLORS THAT SPEAK AND WHAT THEY SAY**).

COLOR KEY

When discussing photography, there is one more idea to be familiar: color key (high key vs. low key). **High key photography** refers to photos with pale, bright tones, where the sheer brilliance of the light is eye catching. These are not overexposed images, just images with lots of bright tones included. In nature this can easily happen using any reflective surface such as fog, mist, snow, sand, or water. High key photos imply lightness, delicacy, happiness, or heat.

Creating high key photography can fool the camera's internal light meter. Remember the camera's meter is trying to produce an overall 18 percent gray tone in the final image. A high key image is considerably brighter than 18 percent gray, so you must override the camera and bring up the exposure yourself to match the scene in front of you. If you are using any exposure mode except Manual, you can use the Exposure Compensation setting on the camera to *increase* the overall exposure by +1 or +2 stops (repeat: we need to *overexpose* or let in more light to

-2 EV 0 EV

Low key images are images full of dark tones. This black on black scene requires a -2 exposure value (EV) to accurately render the blacks as black (right) instead of 18 percent gray (left).

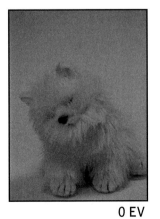 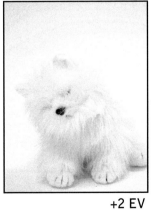

0 EV +2 EV

High key images are white on white. Make sure you overexpose, whether in the exposure compensation or manually, to correct for the camera rendering your scene in 18 percent gray.

compensate for high key photography). While the camera will think this is an overexposed image, you and your thinking brain will know that this merely compensates for the failings of the camera, the tool, to create correct exposure for this particular subject/scene.

If you are using the manual setting, you have full control over exposure. Merely adjust the settings to give you the exposure you want. Many digital cameras will still meter the scene and give you a reading that you can use to double-check your figures. The camera may be blinking that you are 2 stops overexposed, but you know you are correctly exposed for an overly bright subject.

Low key photography refers to photos with deep, dark, tones with many shadows and few highlights. Low-key photos have a mysterious aura about them; they are dark and dramatic. It is important to note that low key photos are again the product of the light's quality and not the camera's exposure; this is not an underexposed photograph.

Low key photography can also trick the camera's meter which is also fixed by using the Exposure Compensation or manual settings, same as with the high key image, except that this time you should be bringing the exposure down by -1 or -2 stops to darken the image. Low key images are darker than 18 percent gray so we have to *decrease* the overall exposure (repeat: we need to *underexpose* or let in less light to compensate for low key photography). While the camera will think this is an underexposed image, you will know that this merely compensates for the camera trying to make this scene too bright.

This image is overflowing with pinks. The warm, sweet, and friendly color enhances the feel of those characteristics in the image of the young girl.

CHOICE - CREATING A MOOD

Colors themselves can evoke specific moods and emotions. Various color combinations can do the same. In photography, you want to try to use color to help evoke the mood that you want to underlie the message of your image. If you want to show the exciting and energetic nature of the Xtreme sports you are watching, include lots of vibrant colors like reds and high color contrasts. If you want to show the soothing nature of the peaceful stream you are vacationing besides, use greens and blues and color harmony. Watch out for colors that do not fit the mood; if the mood is soft, avoid overly bright energetic colors. Color is just one more tool that you can pull out to speak to the viewer.

CONCLUSION

So, to put it all together, you should always strive to create a mood or evoke feelings with your photography and one way to do that is to use color. The psychology and use of color is an important area to study, as the colors in your image will have subconscious effects on your viewer's emotions and pleasure in viewing your image. There are several ways to use color, from choosing to compose with color harmony or color contrast, to adjusting your white balance to optimize color, or using a small spot of color for a subtle effect. Make sure that you are consciously using color (or removing unwanted artificial color) to help show the viewer the overall message of your image.

6 Composition & Visual Design

"When we look at a painting, listen to a piece of music, read a novel, or watch a movie, we are taking in the artist's composition. The composition is the totality of the work." ~ Mike Svob

Just as writers use words to take their readers through a story, photographers use composition in imagery to take our viewer on a journey. You, hopefully, have a reason for taking the image – a story to tell, a message to give to the viewer. This message can be as simple as showing the beauty of the subject or it can be as complex as a political statement. ***Composition*** is the placing of objects and elements within the frame in a visually pleasing way to best emphasize your subject, to share the mood of the location with the viewer, to evoke an emotion, to share a moment, or to send a message to the viewer. You will create your own individual style based on your perceptions of the world; remember, there is no reality, you create your reality. Besides, the best images include an interaction between the viewer and the subject through the eyes of the photographer. So, you have to put part of yourself in your work. There are some basic, universal, visual appeal guidelines, however, to remember as you develop your own style.

CHOOSING THE SUBJECT

Every photograph has to have a subject. Why are you taking this photograph? Is it to capture the beauty of the scenery? Remember a moment in history? Document what someone looks like? What is the subject? This subject should be something easily defined, something that can be summed up in one short phrase or sentence. If you cannot easily define the subject of the photograph, continue to explore your options. Subjects can be easily defined like individual people or objects, or they can be more abstract concepts such as the joy of parenthood or the destruction of pollution, or they can be emotional reactions, which are harder to define (see *Composing with Mood*). Once you know what the subject is, you must begin designing the composition to best express that subject.

FORM / ANALYZING THE SUBJECT

Every photograph has to capture the interest of the viewer, then keep that interest within the frame so the viewer really explores the image instead of simply glancing at it and continuing on to the next image. You can use several methods of design and composition to help you get and retain that viewer interest. When looking at your subject, it can be very helpful to break down the subject matter into its base components so you can use those components to lead the viewer through the image.

SHAPES

Often the best compositions are the simplest ones. There are 3 primary **shapes**: *circle, square,* and *triangle.* Try looking at

> **Technical Tip:**
> You can partially or fully block the sun with elements of the composition to create interesting forms and compositions based around shape.

Notice the neat, clean **graphic shapes**, the two large circles leading you back to the triangle at the peak of the barn. The three shapes form an implied diagonal line through the image from bottom right corner to top left corner.

This soothing **C-curve** (left) leads the eye straight to the small shack at the top right of the frame. These tall, **vertical lines** (right) give a sense of strength and order to the image.

objects without labeling them (tree, house, or ball) but simply as shapes (triangle, square, circle) for easier composition. Use these shapes to lead the viewer through the image to the subject.

LINES

Lines also make good compositions. Lines can be found many places from nature to man-made structures. Examples of lines in photography would be a row of tall trees, a winding, curvy road or path, a stream, the lines on the side of a building, or a close up of fern fronds (leaves). Different types of *lines* convey different messages.

Bold, *vertical lines* convey height, stability, or strength. They jut high into the sky and show longevity (the taller a tree is, the longer it has been there). *Horizontal lines* show stability and fill the composition. They are the wide expansiveness of the horizon, which reinforces peacefulness. They expand. *Diagonal lines* imply instability, movement, or something dynamic. You have the expansiveness of the horizontal line but it has fallen; it is in motion. This gives a sense of

visual tension and energy to the image. *Jagged and zigzagged lines* show busyness, tension, and a little chaos. They have all the energy of the diagonal line, but also abrupt stops and changes of direction. *Straight lines* tend to be a bit more rigid or inflexible than *curved lines*.

Curved lines can serve many purposes as well. These lines work great as *leading lines*, lines that lead the viewer into and around the image. Smooth, gentle, curved lines convey sensuality, gracefulness, and peacefulness while tight curves or re-curved become a bit sinister (like a snake.) *S-curves* and *C-curves* are very common curves that are very visually pleasing. Look for S-curves or C-curves in landscapes especially.

Creative Tip:

Simplify your compositions by using subjects with only a few graphic shapes and a background that doesn't distract from the subject.

The **pattern** of these trees makes for a striking composition. Varying the shades of green and the shape of the trees gives the image depth.

PATTERNS

Patterns are specific configurations of visual elements – a design made from shapes or lines. We have been taught since elementary school to see and recognize patterns. These patterns give us a sense of stability and order from chaos. Rhythm is a pattern repeated at regular intervals. These both bring a sense of dynamic movement to the photo. This gives us the order of the pattern in a repeated cycle.

TEXTURES

Textures or the feel of a subject can create wonderful visual imagery. Sometimes what we like in the scene in front of us has to do with senses other than the eyes. Enhancing the feel of a subject can make the subject pop off the page.

This image shows the **texture** of the scratchy rust and the metal links.

Texture can show the rough, scratchy lichen on the rock as well as the soft silky fur on a champion pedigree dog or the slimy, murky swamp water. Textures unite our senses for a more complete viewing experience.

OBSERVE:

When you come across a scene that screams to be photographed, go ahead and take that immediate image. You never know, what you loved about the scene could have been a fleeting moment, a brief burst of light or stillness. Then, take some time and really look at the scene. Ask yourself several questions about your scene. What am I photographing? What is the subject? What shapes, lines, or other elements are present? What do I like about the scene? What are the elements here that express a mood? What grabbed me in the scene?

PLACING THE SUBJECT / BUILDING YOUR IMAGE

Now that you have broken the image down into its component parts, you can begin deciding how to place those parts in the overall composition. When first designing your composition, you must make several choices about what you want to express in the finished photo. The first of these choices is what angle you want to photograph your subject from: looking up, straight on, or looking down. Next, you must choose what level you want to photograph from: high, eye level, or low. Another choice you have is how far away from the subject do you want to be: close, medium, or far away.

This can seem like a lot of choices, but when you are composing your photo, just look at the subject from different perspectives, move around the subject, photograph downward or upward, etc. The point is to try things out before snapping that final shot. Or if you use a digital camera, try taking the picture several different ways to see which works best for your composition.

These two images were taken at the same time, one right after the other. The only difference is the **horizontal vs. vertical framing**. Notice the difference in feel of the two images.

HORIZONTAL VS. VERTICAL COMPOSITIONS

Make sure to check out the composition in both a vertical and horizontal format. Often, the different frames create a vastly different image. Also consider the final purpose of the image as some destinations require a particular format. Having a vertical and horizontal version of all of your compositions can vastly increase your portfolio's versatility.

RULE OF THIRDS

The **Rule of Thirds** is a good, general guideline for composition. The human eye enjoys viewing pictures that can be separated into thirds both horizontally and vertically. Imagine a tic-tac-toe board laid over your image, with each of the lines one third of the way into the image. Once you have mentally separated your composition into thirds, place points of interest (interesting or important parts of the composition or subject such as the eyes of a portrait) on the places where your lines meet, called **power points**. These are the most visually pleasing areas.

The lines of this image correlate with the **Rule of Thirds**. The line between the dock and the water falls on the lower horizontal third while the far shoreline falls on the upper horizontal third. The two main elements, the chair and the cabin are placed on opposite Power Points.

The **odd number** of trees in the foreground of this image help grab and hold the viewer.

RULE OF ODDS

The **Rule of Odds** says that we prefer to look at subjects in groups of odd numbers more than groups of even numbers. So, it is more visually appealing to look at a group of 3 flowers than 4 flowers or one large rock over two smaller ones. This uneven number gives a sense of dynamic tension and energy to the overall image.

The tree and branch form a natural **frame** around this couple, giving a sense of privacy, as though we are capturing a private moment.

FRAME THE SUBJECT

Some images benefit from wide open skies while others benefit from using frames that surround the subject. Framing fills the empty space around the edges of your image and creates a sense of depth, giving a foreground to the subject in the background, or vice versa. However, don't overuse this technique as it can add clutter or compete for attention. Only frame when it enhances the subject.

EMPHASIZING YOUR SUBJECT

Like everything in life, all good compositions have properly *balanced order and tension* (simplicity and dynamics). Each element of the image has **visual weight** to it, a visual pull, which is dictated by its location in the image, its color, and/or its size. The more the object draws your attention, the greater its weight. In photography we try to achieve balance between various elements in the image by manipulating the subject's weight, dominance, and proportion. These things help to emphasize the subject in the photograph.

DOMINANCE

In every picture, some aspect of the composition influences the composition more than all the other aspects. This is the ***dominant element***, the first thing your eye will go to when viewing the image. This is the part of the composition that influences the image more than any other part. It can be made dominant by color, size, and/or shape.

Your first goal should be to try to make the main subject the dominant element in the image. A bright red flower looming close to the camera is obviously the main subject. Another options would be to place an object in the foreground to create foreground dominance in a distant, and otherwise flat, landscape. Adding a bush of brilliant purple blooms in the foreground of a mountain landscape gives the mountain something to loom over.

PROPORTION

The amount of space given to, or the ***proportion*** of, each of the major and minor elements in the composition will determine the balance of the overall photo. Emphasize dominance by emphasizing the subject's proportionate size in the photo – make something bigger in the picture to make it seem more important. You can also show scale with proportionate sizes of the various elements.

Look closely, you can see little people in red jackets to the right of the waterfall and a person in a yellow jacket behind the falls. Showing the **scale** shows the massive power of the falls.

because it implies tension. The direction a living subject is facing also influences the balance of the composition, the viewer will follow the subject's gaze. Some say that elements have more weight if they are on the left side of the frame as we read from left to right.

BALANCE

Dominance is held in check by balancing the dominant object with the other elements in the composition. This can be ***symmetrical balance*** (the same amount of visual weight on both sides of the image) or ***asymmetrical balance*** (different amounts of visual weight on each side of the image.) Asymmetrical balance is often more dynamic

CREATING THE 3RD DIMENSION

In order to effectively design a photograph, you must understand that the camera makes a 2-dimensional representation of a 3-dimensional space. Everything in the photograph was originally an object with 3 dimensions: height (your feet to the top of your head), width (from shoulder edge to shoulder edge), and depth

(from the front of the chest to the back of the bottom.) The final product, the photograph, is a 2-dimensional representation of that 3-dimensional space; it lacks the third dimension of depth.

However, when you understand how the camera will interpret that 3-D space into a 2-D photo, you can design the photo so it seems to have that third dimension again. You can create the illusion of depth, creating the 3rd dimension in your imagery.

PERSPECTIVE

Remembering perspective is important to good compositions as it will define how the picture is viewed by the audience. **Perspective** is an optical illusion that gives depth to a 2-D image; perspective provides visual clues giving the illusion of depth (lines converging at vanishing point, distant objects smaller than close ones, etc.). There are several different types of perspective including **Differential Perspective** (the sense that objects get smaller as they get farther away), **Aerial Perspective** (shown in changing tones as objects get farther away), and **Atmospheric Perspective** (the subtle blue tint of objects at great distances).

You create perspective by manipulating the elements within the composition. Changes in perspective require changes in your distance or angle to the subject; it requires you to move. Perspective changes will not be seen simply by changing focal length of the lens (zooming in or out).

Several things affect our perspective of the objects in the photograph. Harsher light makes more noticeable tonal contrast, which enhances depth perception. Clearly defined and outlined subjects seem closer than those out of focus (unless the out of focus overlaps the clear; then we assume it is a foreground and mid-ground). Larger objects are seen as closer than smaller objects (called **Differential Perspective**). The lower half of the picture is seen as closer than the upper half.

The **differential perspective** in the fence line (it gets smaller in the distance even though we know the fence is made of wood that is the same size) shows depth, the 3rd dimension, in the image.

We can see the **atmospheric perspective** in this image. Notice the blue tinge to the distant mountains. This helps us see depth and distance in a 2-dimensional image.

Colors and tones can also effect our perception of perspective. Generally (with exceptions) warm colors seem to come forward while cool colors will seem to recede. Saturated colors come forward while muted tones recede. As objects in the composition move farther into the background, they tend to lose color saturation and detail and blend to middle gray. There is less light so there is less detail. We call this *Aerial Perspective.*

At great distances from the camera, there is an excess of particulate matter in the air. The light wavelengths get scattered and the distance seems to have a bluish hue to it. This is the shorter blue wavelengths showing through. We call this effect *Atmospheric Perspective*. This can also show depth in the image.

LEADING LINES

Leading lines can add a sense of depth as they meander around, leading the viewer through the image, getting smaller as they go. Lines that lead into the image give a sense of mystery and intrigue. Where does the line go? What is just beyond that ridge? Lines that lead out of the image can cause the viewer's eye to leave the image, losing your viewer's interest in your work. So, watch out that your leading lines do not lead the viewer straight out of the image.

DISTORTION

Distortion of visual elements can create perspective in a 2-D image, or it can become a distracting element of the image. Lens choice affects the amount of distortion you have in your final picture. Wide-angle lenses show noticeable

Notice how the tones vary from dark black in the foreground to mid grey in the mid-ground to light in the background. This **aerial perspective** (variation of tones) helps us distinguish depth in the image.

This **leading line** takes you from the lower left corner of the image, where psychologists say we are most likely to enter the image visually, and takes you around the image, eventually leading you back into the depth of the trees.

elongated or exaggerated perspective, making the elements in the composition seem more spaced out than in the scene in front of you. This can make your scenic appear vast and wide with an exaggerated foreground element showing off the spacious landscape. However, it can also stretch the foreground from the background on a person's face as well, making the head appear to stretch from the nose to the back of the head. This type of distortion is not very attractive or flattering to people.

Wide-angle lenses also create *converging verticals*, where tall buildings or trees appear to bend together at the top. These distortions can help you increase the sense of depth or 3rd dimension. Ultra wide angles also show a *barrel effect*, bowing verticals outward towards the edges of the frame. This distortion tends to appear odd

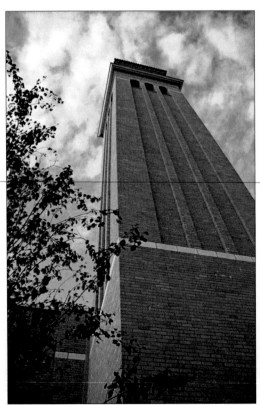

These strong **converging verticals** help enhance the sense of the extreme height of the building.

to the viewer and unnatural, so use it on purpose, for creative effect, and not accidentally. Reduce the barrel effect by placing tall verticals towards the center of the frame. Conversely, you can also choose to use it for creative impact in the image.

Telephoto lenses show a *compressed perspective*, seemingly shortening the distance between the background and the subject. This looks especially good when working with portraits as the compression renders facial features much more accurately. These lenses also show considerably shallower DOF than wide-angle lenses. This can help you reduce distracting backgrounds to a wash of colors.

DISTRACTIONS

Sometimes creating the 3rd Dimension comes with pitfalls, small issues that human eyes recognize as on two different planes but the camera's single lens sees as on one plane. *Distractions* are anything that detracts attention from the main subject, without purpose. Photography is different from other artistic mediums. We do not work solely from imagination, creating on a blank slate; we work with the scene in front of us. This means the camera can catch details that your perceiving brain is choosing to filter out. Watch for distractions in the backgrounds: orange construction cones, a soda can under a leaf, distracting twigs, etc. Many compositions can be enhanced by simplifying. This helps remove any unnecessary clutter in the image. Remove these things from the scene before you take the image.

> **Technical Tip:**
> A wide angle lens, when used close to foreground subjects, will appear to increase the space between the foreground and background objects – elongated perspective.
>
> A telephoto lens will make the background elements loom large against the foreground objects, compressing the space between foreground and background objects – compressed perspective.

Notice the difference a slight change in background makes, removing **distractions** and simplifying the image.

MERGERS

Mergers happen when an object in the foreground is superimposed over an object in the background so they look connected. Mergers can make for silly mistakes, like the appearance of a tree growing out of someone's head. Or they can seriously interfere with perspective if the colors, tonalities, or shapes of the subject and background object are similar enough to hide the edges that separate the two objects. Either way, you should check all compositions for accidental mergers before pressing the shutter button. You can also utilize mergers for interesting creative effects such as holding the Eiffel Tower in your hand or leaning on the Leaning Tower of Pisa.

THE CHOICES:

What exactly is the subject? What are you photographing? Using shapes and lines, the Rule of Thirds, the Rule of Odds, dominance and balance, choose where you want to place the subject and other elements to best emphasize it and its characteristics. Is the subject dominant? Is it balanced?

How can you add perspective, the illusion of depth, to your images? By the size of the elements or using converging parallel lines? Can you use distortion to enhance perspective? Have you watched out for mergers and distractions?

CAPTURING THE MOMENT

Part of photography is also being at the right place at the right time. You can have expert knowledge of lighting, color usage, and composition but if you can't find the grizzly bear to take an image of, all that knowledge does you no good. While some people rely on luck to be in the right place at the right time, you can also use your abilities to research your subject to determine when and where you want to be. Knowing the habits or cycles of your subjects will help you find them and photograph the interesting moments of that subject; we call these *peak moments*. The idea is to know what you want to photograph and then figure out when and where that is. If you want to capture newly born cubs,

you have to know what time of year they are born. If you want to capture rhododendrons at full bloom, you have to know what month they are ready.

Whatever type of photography you are interested in, research a little and determine when the peak moments are. For example, in a wedding there are several peak moments – the moment the groom first sees the bride, the first kiss as man and wife, the bouquet toss, etc. In photographing grappling tournaments (a form of wrestling using joint locks), peak moments can consist of the extension of a limb in a submission technique or a takedown with feet flying through the air. Wildlife peak moments can consists of births, mating rituals, fights for dominance, colorful displays, etc. Find the peak moments in whatever interests you and work on predicting when they will happen and photographing that exact instant.

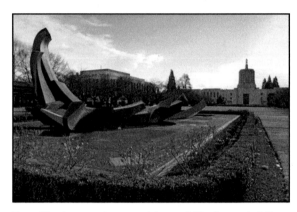

Peak Moment Tip:
Rainbows form opposite a sun lower than 42 degrees. When the moisture particles in the air are large enough, the white light refracts into a rainbow. A circular rainbow is called a broken specter.

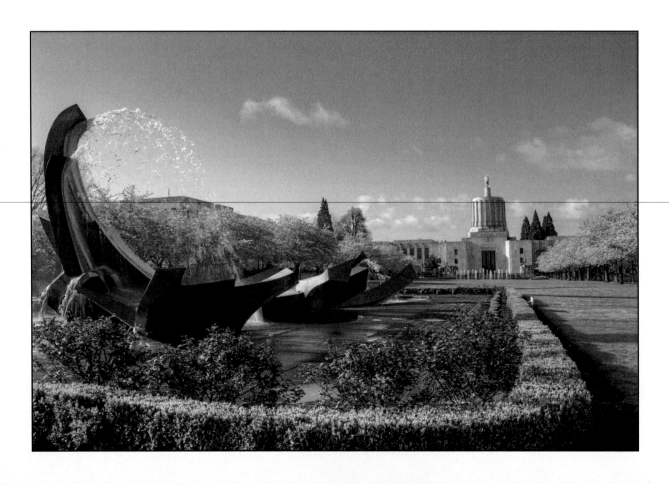

Everything has a **peak moment (or peak time)**, even buildings. Always try to find the best time to photograph your subject; find the peak moment.

This image combines color harmony for a soft peaceful mood, a shallow DOF for a dreamy appearance, a peak moment of action when the girl reaches for the flower, and a sense of perspective with the path behind the girl leading off to the distance. All these elements work together in unity to create a overall **mood** of a cute little girl's curiosity about the world.

THE CHOICES:

What are the peak moments you are looking for? When is the best time to photograph the subject you wish to capture to get those peak moments? Season? Month? Day? Time of day?

COMPOSING WITH A MOOD

There are many aspects of photography, many choices to be made, many things to pay attention to. Try to tackle one aspect at a time until you feel comfortable with not only using the camera, but also watching the light, understanding color, and designing images. Once you are familiar with these things, putting them all together into one coherent message becomes second nature.

Good photography is a combination of a variety of factors. When creating a photograph, use all the visual aspects of photography (light, color, composition, etc.) together to create a mood or theme. For example, you can create the feeling of serenity or peace by using harmonious colors, soft lighting, and curving lines. Create the feeling of strength using vertical lines and bold colors. Create movement or life using diagonal lines, bold colors, and/or motion.

Take a look at what you have available to you in the scene. What elements are present and how do they show the mood you wish to express? One of these things will best represent the mood or theme you are trying to create. Use that as your center of interest, the main focal point. Emphasize its characteristics to enhance the mood.

Great photography combines a larger number of these factors. Great imagery combines perspective to give depth with an interesting angle (and distance) of view to the subject, adding beautiful light and vibrant color, and shows form and a leading composition while capturing a peak moment. Put it all together. The more factors that come out beautifully, the better the overall image.

THE CHOICES:

What is the mood or theme of the image? (Ex: isolation, pollution, rebirth, etc.) What is the subject matter at hand? What is here that expresses that theme? (Ex: a bleached skull, a trash heap, a new plant sprouting, etc.) What should be the center of interest, the one thing that best represents the theme? If there is not a single thing, is there a group of things that combined can be the center of interest? Where should the center of interest be placed in the picture? How big should it be in the picture?

LAST MINUTES CHECKS

After framing your image, but before pressing the shutter button, do a last minute check to determine if you are forgetting anything. Check for these things:

1- Is there a clearly defined subject? If not, can you simplify the composition by moving closer?

2- Are there background distractions or mergers?

3- Will my settings produce the effect that I want in the photo?

4- Are there bright or dark areas that will throw off my exposure.

CONCLUSION

Remember that the point of composition is to lead the viewer of the image around the image to show your message, your expression of the subject. There are 4 keys to a great image composition: 1) appropriate lighting for the subject (which we have already covered in Topic: Light); 2) a clearly defined subject (you should be able to explain what the subject is in a few words); 3) effectively used foreground and background elements that lead the viewer through or around the image and give a sense of depth, and; 4) proper conditions for what you want to photograph (having no breeze for flower macros, good skies for landscapes, etc.) These conditions are all situational and the trick is to know when to shoot certain subjects and when to leave them alone in favor of something else that will photograph better in the current conditions. Previous research can help determine where and when you want to show up.

7 Creativity

"I didn't want to tell the tree or weed what it was. I wanted it to tell me something and through me express its meaning in nature." ~Wynn Bullock

Many new photographers get caught up in the technology, needing this new lens or that new lens, trying to find new ways of expressing themselves. They fail to realize that you can expand your creativity without having to expand your equipment base. Sure, new equipment can help expand the possibilities in some situations, but real versatility comes from within the human mind.

Remember when we discussed the idea that reality does not exist? Your own perceptions of the world, the other people in it, and your own reactions to stimuli all help to dictate your own personal reality. It is these perceptions, this personal sense of reality that creates your own style. In exploring photography, you will discover what you enjoy working with and what is not quite up your alley. You will determine what you commonly use for camera settings, what equipment you like to use, what subjects you prefer to photograph, whether you like images a bit lighter or darker than others, etc. This is your style and it will develop as you learn. One main way to enhance the creation of your style is to stretch your creativity.

Creativity is…. Well, what exactly is creativity? You ask a room full of people that question (as I do every term) and often get blank stares in return. What is creativity? The simplest answer I can give you is that creativity is doing something new. Creativity can be doing something that no one has ever done before, doing an activity that has been done but doing it in a new way, or thinking about a problem or issue from a new direction.

It can seem difficult to do something new when you look around at all the things that others have done, but remember that each of us comes with a unique perspective and life experience to draw on to create our images. Take the time to go past the obvious and look at the subject in your own way. If nothing else, creativity is doing something that is new to you. Even if someone else has done something similar, you will add your own flair and style, which will help you build your creativity even more.

Your creativity rests in that place inside yourself where you imagine stories, drawings, doodles, paintings, etc. Photography, like any other art, can be a strict representation of the world around you (and if you get in to fields like photojournalism or product photography then your photos had better do this). However, images can also be a creative interpretation of a realistic scene. They can even be an impressionistic expression of a mood, music, anger, or some other intangible feeling or thing. Digital photography can be whatever you want from it; all that limits it is your own imagination.

Now that you have learned how to "correctly" use the camera, let's learn how to break the rules and have some fun with it!

PARADIGM SHIFT – NEW WAY OF LOOKING AT THINGS

The first way to begin exploring your creativity is to change the way you think. To use a business term: think outside the box. Everyone approaches life based on the experiences and perceptions that he or she has had, his or her own reality. These experiences have created habitual patterns in us that can help us perform minor tasks (such as fixing breakfast or driving to work) with little to no thought. Can you imagine how long everything would take if we had to re-learn how to brush our teeth every day? We create subconscious patterns for many things in life, from our route to work, to our interactions with other people, to our stereotypes and expectations of others, to our feelings about ourselves, to our reactions to political parties, etc. While these habitual patterns can help us with the little things, they can hinder our personal progress if we rely only on those ingrained patterns for all our decisions instead of thinking past them and evaluating each new situation individually before making a decision.

Many of these ingrained and habitual patterns can hinder our creative growth as well. The brain knows what it is looking for, so it ignores the excess stimuli in order to more effectively find and label our target so we know how to react to it. The brain is trying to run most efficiently. We are bombarded with an overwhelming amount of stimuli every moment of every day. Between radios, traffic noise, billboards, televisions, neighborhood animals, sensory input such as smells, aches and pains, the touch of clothing, etc. the brain is constantly receiving stimuli. It has to determine which stimuli to consciously pay attention to and what to ignore. While the brain means well, we

shouldn't run our lives on auto-pilot. Take care to see what is actually there, and not what you are expecting to see.

Breaking out of those habitual patterns is the first thing to do to increase your creativity. For life in general, try taking a new route to work tomorrow, eating something new for lunch, or approaching a problem from a different angle. See what is in front of you and form your opinions and beliefs on what is there, not what you expect to be there. In photography, breaking our patterns means looking beyond the first impression and finding a new interpretation of the scene. Do not let the camera block your seeing, your enjoyment of the experience. You will get more from the imagery if you focus on having the experience and let your photography be a secondary thing. When you do this, you will be able to photograph your experience at the location, instead of just the location.

DOCUMENTING VS. INTERPRETING THE SUBJECT

Documenting the scene in front of you can be a good way to start your photography session. After all, you can easily start with the basics we have covered so far. However, after documenting your subject realistically, interpret the scene. Take time to explore the scene before photographing it. What does the scene mean to you? Every photograph should have a purpose, a reason for existing. Why did this particular subject grab your attention? Sometimes strict documentation of a scene is not the best way to show your audience what the scene means to you. Sometimes a more creative approach is needed to really show the viewer what it means to you.

Creativity is especially useful when you want to express some feeling or emotion. Study your subject or scene for a moment and ask yourself: How does it make you feel? Happy, sad, reminiscent? What elements in the scene give it that feeling? Color, sunlight, wind? How can I show that feeling to another person? Begin to design the image by determining which settings will best show that mood. Do I want motion blur (a slow or fast shutter speed)? Would a tripod help? What depth of field (aperture size) would best fit the mood?

In order to truly interpret the scene, you must go beyond the obvious. Be patient and don't try to rush through your photography. Good photography takes time and patience to achieve. There are those images that just jump right out in front of you and all you, as the photographer, have to do is press the shutter button, but those are few and far between. These types of images usually come from capturing a peak moment that does not give you time to set up for; you simply must take the image before it is gone. An example of this would be a piece of an iceberg breaking off and crashing into the water or the sudden appearance of wildlife. These things will be gone if you take the time to debate every setting and decision in the photographic process. However, most images are not like this; most take planning, patience, and exploration to determine the best angle, the best lighting, and the best interpretation.

An easy way to start the creative juices flowing is to vary your angle, distance, and level in relation to the subject. Many new photographers simply photograph the subject as they see it with their eyes. You can easily change the perspective of the image by simply moving around.

Vary the *angle to the subject* by stepping to the left or right; even a small step can drastically change your viewpoint.

Vary your *distance from the subject* to the subject by either stepping closer or farther away or using a zoom lens. You can choose to show the subject as a small piece of the overall environment or allow it to fill the frame. If function is an important piece of the subject, then include the overall shape, but if not, then you can go in even closer and look for shapes within shapes, forms within the subject.

Changing the *level of yourself in relation to the subject* can also have a dramatic difference on the perspective. Many new photographers simply photograph everything at their eye level; try squatting down, lying down, or standing on a chair or ladder. How does the perspective and the subject change as your relative position to it changes?

Another relatively easy way to jump-start your creativity it to tell a story by focusing on peak moments. How does the subject fit in with its environment? What is its place in life? What story does it tell and how can you capture that story with your camera? For example, every wedding has a different story to tell. Sure, each wedding has similar parts (ring exchange, vows, kiss, celebration), but each wedding is created by the couple getting married and each couple is different, not only in who they are as individuals, but how they interact as a couple, how they think about life, what they see as a celebration, etc. Does the bride take hours or minutes to prepare? Is the couple loud and boisterous or solemn and quiet? Are there many small details that were planned or was the event quickly thrown together?

What kind of details do they choose? All these things help to tell the story of the day and of the couple. Photographing that story should then include all of these details as well as the overall events of the day. This is a long and complicated story. Not every story has to be so full.

Another example of telling a story would be to show the struggle of the ant as it slowly but steadily gathers food for the queen. Or how about the gripping tale of a solitary flower's struggle for life in the freezing winter snow? Or the joy and excitement of a dog whose owner just came home from a long day at work? How about the tears and heartbreak of a military wife awaiting the return of her overseas husband? Life is full of stories, you just have to find them. These stories pass quickly though, so be prepared to catch them when they happen. This can take practice and some pre-planning.

One thing I want to make clear here, is that you must be okay with "failure" – with an image not turning out exactly as you planned. If you like everything you have done, you aren't pushing yourself enough. When exercising your creativity you will come across images that take your breath away. You will also come across images that you simply don't like, a technique that doesn't work for this subject or for your artistic style in general. That's okay. You must move out of your comfort zone in order to grow. Eventually, as you continue to try new things, you will figure out which techniques you really do like. Just avoid those habitual patterns. If your work starts to look or feel the same, branch out and try new things – get creative.

Exploring One Subject -Taking the time to fully explore your subject from every angle and viewpoint allow for more creativity and a more varied portfolio.

Try to vary the angle of view, distance of view, and level of view for a wide range of interesting images of the same subject. Spend a good 30 minutes or more just exploring and looking.

Exploring a Small Area - You can find many interesting images if you take the time to look around and explore your area.

My area

Look for close-ups as well as more distant images. Textures, shapes, and colors become very important.

Even changing the focal point slightly can introduce new elements like this hornet's nest deep in the pipe.

THE CHOICES:

First, in life, choose to see what is, not what you expect. Then, for individual images, choose between different angles, distances, and levels of viewpoint for the subject. Also, look for peak moments for the highest drama in your imagery. Having an idea of what those peak moments are ahead of time will help you in predicting when they will occur so you can be prepared when they happen.

EQUIPMENT TECHNIQUES FOR CREATIVE INTERPRETATION

Now that we have discussed how to open your mind to new possibilities, let's explore some equipment-related tricks that can add to your interpretation of events and scenes. Throughout the rest of the book, we have discussed how to use the camera and equipment "correctly" to give you "good exposure", "proper WB", "good" clarity, etc. which is all supposed to increase viewer interest. I have set forth guidelines to increase visual appeal, but these are only guidelines. Now let's try breaking these guidelines to increase creative thought. Remember, this is by no means an exhaustive list of creative ideas, this is just a starting point for you to break into your own creative mind. (Note: some of the techniques discussed here require specialized equipment that you may or may not already have.)

THE CHOICE: ADJUSTING CAMERA SETTINGS FOR CREATIVE PURPOSE

EXPOSURE AND COLOR BALANCE FOR MOOD

Sometimes adjusting the normal, everyday camera settings, even if only a small amount can enhance the mood of a scene. Slightly overexposing or underexposing an image helps to bring an emotional response from the viewer. Overexposed

The mood of this image was enhanced by adjusting the exposure to brighten the highlights to a glowy white and adjusting the white balance to give the image warmth. While it is not technically accurate to the scene I was looking at, the final image shows **an interpretation of that scene**.

images look bright and happy whereas underexposure can make darker, moodier images. Minor additions of warm or cool colors can make an ordinary scene much more dramatic. Peter Jackson made this famous in his trilogy _The Lord of the Rings_ with locations such as Lothlorien which was cold, blue, and dark, Rivendell, which was healthy and glowing with warmth, and Moria which was low in overall color, dark and murky.

LENS DISTORTION

The lens also gives you some creative control over your finished photograph. Different lens' focal lengths give photographs different effects. A wide angle lens ranges between 10mm and 50mm and stretches the horizontal axis of the photo a little. Wide-angle lens when tilted up or down will make parallel

lines converge strongly. These can be used for fun shots very close to your subject. A wide angle lens, with its elongated perspective, can make for amusing images of people whose heads look too big while their feet are far away.

Other lenses can also show interesting and fun distortions that can help you expand your creativity. Macro lenses are specifically designed to shoot extreme close-ups and they have a very limited DOF. Fisheye lenses use a curvilinear perspective that shows straight lines as curves. There is a lens called the Lensbaby that shows large blur distortions. All of these various lenses can be used for creative rendition, but each one is a separate lens, which means another piece of equipment to buy. So, if you have the chance to play with one, either by renting a lens from a camera rental facility or from another photographer, I suggest you take the opportunity as lens are fun to play with.

THE CHOICE: CAMERA & LENS MOTION

Traditionally we prefer to keep the camera still, even if the subject is moving through the frame. This helps retain clarity and show the subject's motion. However, let's break this guideline and try moving the camera around.

PANNING STILLS

Panning is a technique that is used to show movement. For example, you can use panning to follow a bicyclist as he is riding down the street. The bicyclist will seem in focus, but the background will look blurred, showing movement. You can use panning with galloping animals, dirt bikes, running, moving vehicles, etc. When you try panning, use

Using the wide-angle lens to deliberately add **distortion** to this image of the young girl emphasizes her small size and youth.

Panning shows motion in the background instead of in the subject itself.

Creative Tip:
When panning use a tripod and loosen one only axis (right-left or up-down). Practice moving the camera on the tripod before trying to capture the image so you can get a feel for the motion.
Use a shutter speed of 1/mph (speed of the subject in miles per hour). So a cheetah moving at 55mph would show panning motion at 1/55 whereas a bicycle moving at 10mph would show at 1/10.

a longer shutter speed and move the camera to follow the movement of your subject.

To set up for a panning image, set the camera on a tripod (you can do this handheld but it produces up and down movement as well as left to right which creates a confusing image so panning is far easier with a tripod). Loosen the left/right axis on the head of your tripod so you can smoothly move the camera from left to right and back again. Aim your camera all the way to the direction the subject is coming from, use a small aperture such as f/11 or f/16 to give a deeper DOF, and focus on infinity (turning off auto focus after that or the camera will waste valuable time trying to focus before firing the shutter).

As the subject moves in front of the camera, depress the shutter (preferably with a remote shutter to reduce camera shake) and allow the shutter to stay open as you rotate the camera from one side to the other, following the subject. Try different shutter speeds from 1/15 second to 2 seconds for varying effects. You may need to try several shots to get the exact effect you want, especially in the beginning, so be prepared to spend some time practicing.

If your subject is moving vertically, you can try panning up and down instead. Prepare the camera in the same way except loosen the up and down axis of the tripod head instead of the left /right one.

Creative Tip:
When zooming with brightly colored lights, make sure the lights start off filling the frame for the best effect.

ZOOMING

Use your zoom lens to create swirls of light with a technique called *zooming*. With a handheld or tripod steadied camera, use a small aperture and a longer shutter speed and, while the shutter is open, zoom through multiple focal lengths, into a set of lights or bright colors. Try using a shutter of ½ second or longer. Using a tripod will create straight color lines while hand holding your camera will create jagged lines. Try

Zooming. The use of the zoom lens to move the lens while the shutter is open can produce some interesting abstract effects with light and shapes.

zooming in by putting the lens on its most wide angle focal length and then zooming into the most telephoto length while the shutter is open. Then try zooming out starting at telephoto and turning to wide angle.

THE CHOICE: FOCUS

Not every subject has to be in crisp, clear focus. In fact, some subjects may be best interpreted with a little (or a lot) of **creative blur.** Imagine a field of flowers on a beautiful afternoon, the sun warming your face, making you a little drowsy and peaceful. This scene can be interpreted with crisp clear focus, but this interpretation may not fully express the feeling of being there. However, a slightly out of focus close up image of that same field may very well show that sleepy, warm feeling you have while sitting there. There are many fantasy photographers (Suze Scalora comes to mind) who use this technique to great effect. A Lensbaby specialty lens will also create a soft focus effect.

THE CHOICE: PAINTING WITH LIGHT

Painting with light refers to using a flash or other light source to deliberately place light where you want it in the image. You will need a darkened scene for this (if the scene is already lit, you will not see the effect of the placed light). You can paint with light using an off-camera flash by having a long shutter (preferably Bulb setting so the shutter stays open the entire time you are painting) and flashing light onto various parts of the scene. By adding colored gels to the flash, you can add colored light to the scene.

Soft or lack of focus makes for a more abstract image, one based more on mood and less on subject.

However, you do not have to use a flash; any small, directional light will work. Try using a flashlight or penlight to outline the edges of a still life of flowers. Any ambient light will illuminate the flowers just enough to see them, but the pen light will create a neon-light effect.

Photographing fireworks is technically painting with light as well. As the firework spark shoots up into the sky then falls down, it is painting the sky with light in the classic firework blossom. Use a tripod, set the aperture for f/11 or f/16 for clear DOF, set the

shutter on Bulb (meaning it stays open as long as you hold the shutter down), and focus on infinity. Every time you see a firework burst into the sky, use a remote shutter (to ensure image clarity) to open the shutter and hold the shutter open until the firework has faded. Try opening the shutter for several firework bursts.

Be careful of smoke, though. Firework companies add gray smoke to the firework to act as a backdrop to make the colors seem brighter in the sky. However, this smoke makes our images look bad, so try to avoid it in your images. The smoke gets worse as the fireworks show progresses.

CHOICE: PRODUCTION / POST-CAPTURE

Some of the digital photographer's art can take place after capture and in the computer, in post-processing. We discussed earlier the benefits of photographing in RAW over JPG when it comes to post-production editing of your images. Here are a few creative techniques that go above and beyond basic pixel processing and editing and into more digital art concepts.

LAYERED / SANDWICHED IMAGES

Sometimes the combination of two images can create a new interpretation of a scene. For example, if you are studying the effects that a Native American tribe has had on the land, an overlay of a symbol of that tribe (such as a totem or other carving) on top of a landscape image of the tribe's territory can give a new interpretation to the landscape – showing the land and how it influenced the tribe or vice versa.

This *layering* technique can also be used to create Monet-type impressionistic images. Monet used small spots of color instead of full shapes to give an overall impression of the scene he painted. Well, if we overlay several images into one final print, we can emulate his style. This is best done with a scene of many small bits of color, such as a field of wildflowers.

With digital files, you can use a program such as Photoshop to easily overlay the images as multiple layers then adjust the opacity of each layer to the degree you think is best. A good general guideline to adjusting the opacity of each layer is to reduce it 50% from the previous layer. If you are a Nikon user, many of their D-SLRs have multiple exposures as one of their settings – check your manual for specifics of how to use this feature.

HDR

High Dynamic Range (HDR) photography is a big up and coming field. Traditionally, cameras do not have the tonal range that the human eye has, making every image seem lower in contrast than

A **layered image** created from 7 different images of a field of wildflowers.

what the eye sees. Photographers have struggled for years to overcome the camera's tonal range limitations. HDR photography is one major answer for this challenge.

HDR photography refers to the ability to increase the tonal range of the camera. The general premise is easy enough. One digital image taken in RAW has a tonal range of 5-6 stops of light. When the scene in front of you has a higher range of light contrast than the camera can handle, say 10 stops difference, traditionally we would have to accept that either the highlights or the shadows would be lost. When you collect multiple images, you can gather more digital information about the scene's highlight and shadow ranges. Combining those multiple images into a single image would then increase the overall tonal range of the image.

To start playing with HDR, you will need a few things. First, you will need a tripod. Hand holding is not recommended for HDR. When you are layering images over each other, all the images must be exactly the same placement and hand holding, no matter how still you try to hold yourself, produces movements that can destroy a layered image.

You will also need the software to combine, process, and create the HDR image from the multiple originals. Photoshop does have this option available but it is not the top feature of that particular program. Try **PhotoMatix** as this is a program developed solely for the creation of HDR and is highly user friendly.

When you are in the field capturing images for HDR, set the camera on a tripod, bracket your images so you capture an image at 0 exposure

HDR Photography combines three RAW images with different exposure values into one single image with a combined tonal contrast range of the three separate images. Top Left: -2 Exposure Value, Middle Left: 0 Exposure Value, Lower Left: +2 Exposure Value; I combined all three via PhotoMatix Pro and created the above HDR image.

compensation (regular 18 percent gray image), one at +2 exposure compensation, and one at -2 exposure compensation, for a total of 3 images. You can set the camera up to do this automatically for you using the Auto Exposure Bracketing (AEB) feature. You would have to dial in the range of bracketed images you want, but the camera figures out the bracketed settings. This will give you a wide range of tones to work with. Then combine those images in the software program. Each program is a bit different on how it works but generally you can adjust how the software combines the images to create just the right look for your image.

CONCLUSION

So, what is creativity? Nothing more than doing something differently than you have done in the past. Simply responding to the environment as it is instead of responding out of pure habit. Really look at your photographic subject and explore it before capturing it photographically. This will help you figure out how to best interpret it instead of just documenting it. Look at the subject from various angles, distances, and levels of viewpoint. Try telling a story by capturing peak moments.

We also explored some new camera and equipment techniques that can help in your interpretation. Once you are familiar with the basics of photography and how to use your camera, open yourself up to the possibilities. Remember to be okay with experimentation – leave your inner critic at home and allow yourself to just play with the subject. Each of these techniques will probably require some practice and will most definitely require you take multiple images using the technique before you find an image that pleases you. Don't be afraid to capture 20 creative images to get one great one. Remember: if you love every image that you take, you are not stretching your abilities nor are you expanding your creative potential. Have fun and be creative!

8 Putting Theory Into Practice

"Having a camera makes you no more a photographer than having a hammer and some nails makes you a carpenter." ~ Claude Adams

It's one thing to read and understand the intricacies of the camera. It is sometimes harder to remember that information while in the field. Now that we have covered a lot of theory, let's put that theory into action on a photographic excursion.

Before the trip, do your research. Find out when your subject has its peak moments. Visualize what you will find at the site, what types of images you may find, that way you can plan what equipment to bring. What lenses will you want to have? Will you need a tripod? Filters (ND, UV, polarizer) and any required attachments? Remote shutter or other cords? Will you want a lens cleaning kit for on-location cleaning (especially useful for harsh environments like the beach)? Do you have maps and/or guidebooks? Remember appropriate clothing for the weather you will face.

The night before the photo session, charge your batteries, check your memory cards to make sure they are empty and ready for use, gather and clean your gear, and pack your equipment. If you are not sure if you will need a piece of equipment, bring it just in case.

The first thing to do when you arrive in any photographic situation is to evaluate the light. Look at the light; is it bright or dark? How bright or dark? If the light is low, will you require flash? Do you have a tripod so you can use a long shutter speed? Set the ISO accordingly. What is the light source? What kind of light? Man-made, natural? Set the WB accordingly. You can use Auto if needed until you feel comfortable taking over these controls.

Next, evaluate the subject and set the exposure control. Ask yourself: Is the subject moving? If yes, set the camera to Shutter priority to control the rendition of motion. Stop the motion with a fast shutter speed and show it with a slow one (which will require a tripod). A good general shutter speed if you are in doubt is 1/125. This is fast enough to stop most motion and allows hand-holding of the camera but long enough to allow adequate light in to expose the sensor. Adjust the shutter speed for a variety of effects.

If the subject is not moving, set the camera to Aperture priority, which controls DOF. Here a small number gives you a small DOF while a large number gives you a large DOF. So f/2 or f/4 gives a shallow DOF, while f/16 gives you a deep DOF. Unsure of the effect you want? There is an old saying: F/8 and be there!

When composing the image, define the main subject and then place it in a way that emphasizes that subject. Place the main subject out of the middle of the frame for best visual appeal (remember the Rule of Thirds). Watch the background of the image as a distracting background can ruin a wonderful moment.

Once you capture some initial images, start to expand the creative range of imagery. Try to show what the experience is like to be there. What are you doing? What is happening? What is unique? Documenting things like which people were present or what events took place is one thing, but sharing that experience with another takes your photography to the next level.

Here are some examples from a recent weekend trip to Disneyland and California Adventures with my family followed by a nature session.

I started off with some traditional images: Main Street, famous locations, some palm trees (it is California after all), and characters.

The goal was to not only capture the events we attended and the people we saw, but also to bring home a sense of what it felt like to be there; of what the experience was like.

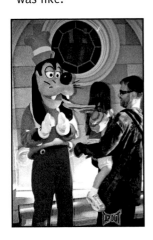

Even though it was early morning, the natural light was pretty bright and full of contrast (notice the bright highlights behind Goofy) so from then on we looked for characters that were in the shade (switching my WB to shade), which has more even tones.

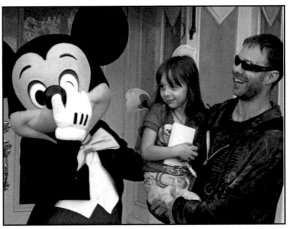

While the subjects were trying to hold still, fleeting expressions and interactions made me choose shutter priority (1/125) to stop the motion of the people.

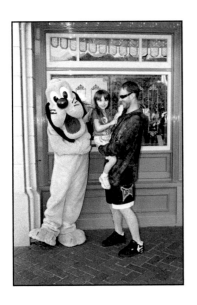

To keep the landmarks clear in the backgrounds, I used a small (f/11 or smaller) aperture for clear DOF.

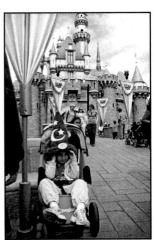

Disneyland is known for its rides. Some rides were slow and tame, while others were fast and furious. I tried to capture the mood of each ride.

A slightly longer shutter speed shows the motion of the teacups as we whirl around and around.

When rides were indoors, I had to increase the ISO to be able to continue to hand-hold the camera while on the ride (also stopping motion even though I was on a moving ride).

When rides were outside, I dropped the ISO back down for lower noise levels and higher quality. I used Daylight WB. A fast shutter speed stopped the motion of this roller coaster.

Capturing the joy of riding always makes a great image.

By the time night fell, I was using a high ISO (notice the noise in the details) along with a fill flash (using Flash Compensation, less intense for the daughter sitting next to me and more intense for the daughter across the rink) to stop the motion of my daughters on the bumper car.

The decor in the various rides makes for interesting memories. These are small details that help enhance the overall story line of the day.

The Electric Lights Parade brought some interesting low-light opportunities.

A medium ISO and a longer shutter speed helped to ensure enough light hit the sensor in the low light. Moving the camera and/or lens created the light streaks. Using Daylight WB helps retains the colors of the parade.

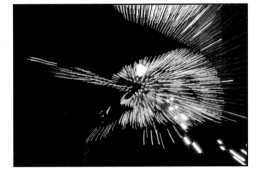

Don't forget to capture the people enjoying the event. Here a fill flash (reduced in intensity using the Flash Compensation with WB set to Flash) shows the family in the foreground with the parade in the background.

The rest of my time was spent looking for those peak moments that make the trip memorable...

Sugar-filled junk food...

New toys...

Humor...

And don't forget an image to close the story out. Stories have a beginning, a middle, and an end. Remember to capture all parts of the story.

Fun filled moments...

NATURE STUDY - Here is a sample of a nature study along Warm River, Idaho.

Look for large scale landscapes as well as smaller, more intimate scenics and close-ups or macros. Each has a place in the full story of the location.

Check out backgrounds before pressing the shutter button. Backgrounds can make or break an image.

The soft, warm morning light helps give vibrance and life to your imagery.

Color also plays a large role in the final image. Always be on the lookout for colors with impact.

Look for natural frames for your subject.

Creative opportunities are all around. Here (right) is an example of Impressionistic-style layering of a field of wildflowers.

Make sure that you explore each subject. Look at it from different angles, levels and distances. You may find that there are several good angles, but one fabulous angle. Remember to create both vertical and horizontal compositions in your exploration.

9 Self-Analysis

"A photograph can be an instant of life captured for eternity that will never cease looking back at you." ~Brigitte Bardot

Every good photographer knows that every image does not turn out exactly as imagined. Therefore, you must learn to edit your images and remove the ones that are not technically as good or that didn't do what you wanted them to do. Consistently re-evaluating your work and artistry allows you to grow and thrive. Finding weaknesses or mistakes allows you to make the conscious effort not to repeat them.

EDITING AND OBJECTIVITY

Once you get back from your photo session, go ahead, look at the images. Go through them at least once to get a good feel for your work that day. You can even go through and figure out which are your favorites for the day. Then, put them away. Don't look at them for two weeks. Edit twice, once the day your took the images for the obvious problems, then a second time, later, for the smaller issues.

It is a good idea to wait several days, even weeks to do the second edit. Why, you may ask? Because we are emotionally attached to our work. We slogged through the mud and muck to get this image, or we got up at dawn and we were cold and tired so the image had to have been worth the hardship we went through to capture it, right? This type of thinking gets us in trouble. We tend to view the image based on the situational factors that surrounded the capture of that image, which can color our judgment of that image. If you wait two weeks to finish editing the images, the situational factors and corresponding emotional and psychological attachment to the image based on that situation will fade, leaving you much more objective when critiquing the image.

Re-Evaluate your Choices

When doing your editing, re-evaluate your choices and see if the image accomplishes what you intended.

You should notice that many of these questions are based on what you intended when you took the image. This is the most important factor in determining the success of an image – did it do what you intended it to do? This is your artistic style, and it will be different for each photographer.

If the image does not accomplish everything you wanted, but it strikes you, keep it a bit longer. Sometimes great images come from unintended results. But most images should come from your knowledge of the camera, light, color, composition, and the deliberate creative usage of these concepts to speak to your viewer.

Ask yourself:

- Are the focus, exposure, and various settings appropriate for the subject?
- Have I used motion rendition or depth of field to capture the most dramatic image?
- Are there dynamic shapes or is the subject torn? Did I choose the best subject to photograph (is the flower wilted and drooping or vibrant and full of life) to best show my interpretation?
- Are there interesting faces or beautiful colors? Something striking?
- Is the light good and effective for the subject?
- Have I used color effectively for my image? Do the color relationships work?
- Does this image express my intent, my interpretation?
- Does the image evoke an emotional response? Was it the response I intended?
- Did I capture the moment successfully? Have I shared a moment?
- Does the image have a clear center of interest?
- Does the image make good use of existing design elements? Is the image well composed, the arrangement dynamic?
- Have I eliminated all the distractions and unimportant details from the image? Does anything detract from the subject? Could the image have been simplified with less clutter?
- Does my perspective give the most impact? Have I created depth?
- Will the image grab and hold the viewer's interest and attention?

If you answered yes to most of these questions, then congratulations, you have a great image!

What Now?

This text was developed to give you the fundamentals of photography. This will give you a good start in developing your own photographic style. But this book cannot begin to cover all the intricacies in the realm of photography so this should not be the end of your studies; continue to learn and enhance all your photographic skills. I tried to present a good overview of photography but it is up to you to determine where your specific interests lie.

That being said, if you have questions that still need answers, I also offer private tutoring (in Northern Oregon), travel photography consultations (if you are taking a trip and want to get the most from your photographic memories), and on-locaton photographic seminars I call Image Experiences. These seminars are designed to help both the beginning and more advanced student develop their skills. Image Experiences go beyond the information in this text by offering specialized photography skills, advice, and in-the-field guidance. If this is something you are looking for, please visit my website at www.lauralawnstudios.com for more information on upcoming Image Experiences and other photography tips, contests, and opportunities.

Now, grab your camera, go out, and have some fun!

Glossary

18 percent Gray - Half way between black and white, 18 percent gray is an exact mix of black and white, an exact mid-tone.

Absorption - When the light energy is absorbed by the subject and never seen again, usually released as heat energy.

Achromatic Scale - A range of tones dealing with shades of gray; tones purely light to dark, void of color.

Additive Color - Mixing primary colors of light together to create successively brighter and lighter tones until pure white is reached.

Adobe Lightroom - Processing software specifically for managing adjustments on many different images at one time

Adobe Photoshop - A large and expensive processing program that allows you to have the absolute widest variety of image processing and composite creation options.

Adobe Photoshop Elements - A software program that is a piece, or an "element" of the whole Photoshop program, designed to meet the needs of the common user instead of the professional user.

Aperture - The hole in the lens that lets light through to the sensor to create exposure.

Aperture Priority - An exposure setting that lets you choose your aperture size while the camera chooses the shutter speed.

Asymmetrical Balance - Balancing the composition with different amounts of visual weight on each side of the image; shows more motion and energy than symmetrical balance.

Atmospheric Perspective - The appearance of a blue color and loss of detail in far distances; shows depth in a landscape.

Automatic / Auto - A setting that allows the camera to make choices for you.

Back Light - Light coming from behind the subject, producing high contrast, often silhouettes.

Barrel Effect - A visual effect produced by wide angle lenses where straight lines seem to bow outward, especially at the edges of the frame.

Brightness - The intensity of the light; generally, the brighter the better.

Bulb - A shutter setting that allows the shutter to remain open as long as you want.

Center Metering Mode - A metering mode that measures the light mainly from the center of the image.

Chromotherapy - The treatment of medical disorders with colored light.

Circular Polarizing Filter - A filter that blocks light traveling in one direction to remove glare from water or glass and deepens color saturation.

Color Complements - Colors that lie on opposite sides of the color wheel.

Color Constancy - The visual perception of unchanged color even though the light on the subject changes.

Color Contrast / Complementary Contrast - When two complementary colors are of equal value and saturation, they will agitate the color receptors in your eye to such a degree that the colors will seem to vibrate.

Color Harmony / Analogous Harmony - A color scheme that uses colors that are next to each other on the color wheel.

Color Temperature - The main color changes that light goes through, based on the Kelvin scale.

Color Wheel - A circular chart that organizes colors.

Composition - The placing of objects and elements within the frame in a visually pleasing way to best emphasize your subject, to share the mood of the location with the viewer, to evoke an emotion, to share a moment, or to send a message to the viewer.

Compressed Perspective - When telephoto lenses compress the elements in the composition so the background seems closer and looms large over the foreground.

Continuous Shooting Mode - The ability to record multiple images in a row, a "flip-book" style series of images.

Converging Verticals / Parallels - A visual distortion caused by wide angle lenses that shows vertical or parallel lines as converging, which helps to show depth.

Creative Blur - Deliberately un-focusing your image for creative purposes.

Creativity - Doing something new.

Depth of Field (DOF) - How far in front and behind the focal point is clear and in focus, showing depth.

Diffuse Transmission - Light transmission where a material scatters the light rays in unpredictable directions, such as through translucent materials.

Diffused Highlights - Bright areas with image detail, which may contain specular highlights.

Diffuser - Anything that can scatter the light waves to give a nice, even light with lower tonal contrast.

Digital Single Lens Reflex Camera (D-SLR) - Cameras that have fully adjustable settings on all features providing the widest range of creative control over the finished photographic image.

Direct Transmission - Light transmission where the light passes through in a predictable path, such as through transparent materials.

Distortion - Visual effects seen in wide angle lenses.

Distraction - Anything that detracts attention from the main subject, without purpose.

DOF Preview Button - A button that closes down the aperture to the correct size so you can look through the viewfinder and determine if the DOF is accurate before you take the image.

Dominant Element - The first thing your eye will go to when viewing the composition, the element with the most visual weight.

Double Complementary Contrast - A color scheme using two adjacent hues and their complements (such as blue-green and blue with red-orange and orange).

Electromagnetic Spectrum - The entire range of light that hits the Earth. We can only visually perceive a small portion of this spectrum.

Elongated / Exaggerated Perspective - When a wide angle lens seems to elongate the various elements in the composition, stretching the distance between the foreground and background.

Evaluative / Matrix Metering Mode - A metering mode where the camera divides the image into multiple sections, meters each section, than creates an average, overall reading for the entire scene.

Exposure / Exposure Value - The overall brightness or darkness of the image.

Exposure Bracketing - A technique where you expose 3-5 images of the same subject and composition, each slightly different in exposure to ensure you have at least one exposure that works.

Exposure Compensation - A setting that allows you to bracket one way only; going only positive or only negative.

Fill Flash - Using your flash to add a small boost of light to the subject, filling in the shadows a little.

Fisheye Lens - A lens that shows a 180° perspective, a curvilinear perspective rendering straight lines as curves (an exaggerated barrel effect).

Fixed Focal Length Lenses / Prime lenses - Lenses that have one and only one focal length.

Fluorescent - A man-made type of light, common in public places such as schools, businesses, malls, rest rooms, etc.; also a WB setting on the camera.

Focal Length - The length, in millimeters, from the focusing point within lens to the sensor of the camera (or film in the old days).

Framing the Subject - Placing a frame or edge around the composition to visually hold in the main subject.

Front Light - Light originating from in front of the subject, facing the subject.

Hard Light - A small light source with nothing between the light source and the subject.

High Dynamic Range (HDR) - A creative technique that increases the camera's tonal range by combining three RAW images into one finished image.

High Key - Images with pale, bright tones, where the sheer brilliance of the light is eye catching. These are not overexposed images, just images with lots of bright tones included.

Hue - The specific color you are using, the red or blue-green.

Hybrid Camera - A camera that combines of the cost effectiveness of the PNS and the camera control of the D-SLR.

Hyperfocal Distance - The distance from the lens to the hyperfocal point.

Hyperfocal Point - The point within every scene that is the perfect spot to focus on to ensure crisp, clear DOF throughout the entire image.

Incandescent - A man-made type of light common in both public and private places; also a WB setting on the camera.

Incident Light Beam - The light that travels from the light source to the subject.

Incident Light Meter - A device that measures the ambient light intensity directly around and in front of the subject, called the incident light beam.

Inverse Square Law - The intensity of the light is inversely proportional to the square of the distance (so a light that is 2x as far away will look ¼ as bright OR a light that is close will be 4x brighter than one that is 2x as far away).

ISO - The light sensitivity of the camera, ranging from low sensitivity (100) to high sensitivity (3200).

JPG - A digital file format that is great for convenience of printing, sharing, and storing. JPG files are smaller, and are also compressed during which they lose some data so they take up less memory card space, but these are smaller files to print with later, meaning smaller prints.

Kelvin Scale - The scale used to determine the color or "temperature" of the light.

Layered Images - A post-processing technique using Photoshop to combine several images into one.

Leading Lines (whether curved, jagged, zig zag, horizontal, vertical) - Lines that lead the viewer into and around the image.

Lensbaby - A specialty lens that gives creative blur.

Low Key - Images with deep, dark tones with many shadows and few highlights; this is not an underexposed photograph, but an image full of dark tones.

Macro Lens - A specialty lens that allows you to move physically closer to the subject for a larger view (up to or beyond a full 1:1 ratio).

Manual Exposure Mode - An exposure mode that allows the photographer full control over both the shutter and the aperture.

Mergers - A visual effect that happens when an object in the foreground is superimposed over an object in the background so they look connected.

Metering Modes - Modes that dictate how the camera's internal light meter reads and measures the light in the scene.

Monochromatic Scale - A color scheme that uses a variety of tints and tones of a single color.

Mood - A feeling or emotion conveyed in an image.

Motion Rendition - How you choose to show (or render) the motion of the subject. Do you want to show the motion or stop it?

Neutral Density Filter - A filter that blocks light entering the lens to reduce the overall amount of light allowing for longer shutter exposures.

Noise - The digital equivalent of grain; red, green, and blue spots in the image; controlled by reducing the ISO of the camera.

Overexposure - An image that is too bright, too much light coming in to render a good exposure.

Painting with Light - A creative, low-light technique that uses a flash or other light source to deliberately place light where you want it in the image.

Panning - A creative technique that uses a long shutter speed to follow the subject with the camera to show the motion of the subject.

Pattern - A series of graphical shapes or lines.

Peak Moments - The time of peak action, the subject is at the peak of movement, life cycle, etc.

Perception - The attempt to understand and make sense of the stimuli received by the brain.

Perspective - An optical illusion that gives depth to a 2-D image; perspective provides visual clues giving the illusion of depth (lines converging at vanishing point, distant objects smaller than close ones, etc.).

Point 'N Shoot Camera (PNS) - Convenient, portable, and affordable cameras with small, pocket-sized frames with multiple user-friendly features designed to assist the beginner who knows little to nothing about photography. They often have a reduced capacity for camera control.

Primary Colors of Light - Light that cannot be broken down into any other colors: red-orange, blue-violet, and green.

Primary Colors of Matter - Colors that could not be broken down any further, but could, in theory, combine indefinably to produce any other hue and when mixed in even amounts would make pure black.

Prime Lenses - See *Fixed Focal Length Lenses*; lenses that have only one focal length.

Program Mode - An auto exposure mode with the ability to override the camera's choices.

RAW - Digital files that allow you to retain the full editing capability of the image and print much larger prints from the files.

Reflected Light Beam - The light that bounces off the subject to travel to the eye or the camera.

Reflected Light Meter - A device that measures the intensity of light that is bouncing off the subject, the reflected light beam.

Reflection - When light strikes and bounces off the subject.

Reflector - A device that helps you direct light in the direction you want it to go.

Refraction - When light rays are bent as they pass through a material.

Remote Shutter - An accessory that plugs into the side of the camera and allows you to fire the shutter without physically touching the camera, reducing camera shake to minimal.

Retinex Theory - A color theory that says that every color will look just a little bit different when placed against different background colors.

Rhythm - A pattern repeated at regular intervals; a pattern of patterns.

Rule of Odds - A compositional guideline that suggests that it is more visually pleasing to have subjects in groups of odd numbers than groups of even numbers.

Rule of Thirds - A compositional guideline that suggests you separate your composition into thirds, both horizontally and vertically, and place points of interest on either the lines or the places where your lines meet.

Saturation - The intensity or the purity of the color.

Shooting Modes - Modes that determine how the camera takes the image: singularly, continuously, or on a timer.

Shutter - The piece that sits between the aperture and the sensor, blocking light to the sensor. The shutter stays closed and in place until you press the shutter button on your camera.

Shutter Priority - An exposure setting that lets you choose your shutter speed while the camera chooses the aperture setting.

Shutter Speed - How long the shutter is open; it is measured in stops.

Side Light - Light that comes from the side of the subject; it skims across the subject, lighting the sharp lines but softening over other features.

Singular Shooting Mode - A shooting mode that captures one image at a time.

Soft Light - Light hitting the subject through a diffusing layer of something, such as fog, smoke, haze, clouds, or fabric such as silk and/or nylon.

Specular Highlights - Pure highlights with no image detail recorded, they mirror the light source, and usually exist within diffused highlights to add depth and brilliance to highlight.

Split Complementary Contrast - A color scheme using one color (ex.: yellow) with the two colors outside its complement (the complement to yellow is violet so use red-violet and blue-violet).

Spot Meter - A device that reads and measures the reflected light off of a specific spot in the image.

Spot Metering Mode - A mode that allows you to choose a specific spot within the composition and meter off that single spot.

Stop - A unit of light that changes in multiples of 2 (1/2 of or 2x).

Subject - The main focus of the image; the reason for capturing that image.

Subject Modes - Exposure modes that allow you to tell the camera what the subject is, allowing the camera to set the aperture and shutter speed to what is commonly desired for that subject.

Subtractive Color - When mixing pigments to create color, the more you add, the closer to black you get. The darker color subtracts the light from the reflected light beam.

Sunny Rule of 16 - On a bright and sunny afternoon, an aperture size of 16 and a shutter speed of 1/ISO (since we are using a standard ISO of 100, we will use shutter speed of 1/100) will result in the proper exposure.

Symmetrical Balance - The same amount of visual weight on both sides of the composition.

Synthesia - Experiencing two different types of sensory perceptions in one stimulus, such as hearing and seeing.

Telephoto Lens - Lenses that have a focal length of 80mm or more. These lenses show compressed perspective, a narrow angle of view, and a shallower DOF.

TIFF - A file format that combines the versatility of the RAW and the smaller size of the JPG, found on some PNS cameras.

Timer Shooting Mode - A shooting mode that allows a brief period of time between the depression of the shutter button and the release of the shutter, usually 2, 5, or 10 seconds.

Tint - The lighter shades of the hue (mix a color with varying amounts of white).

Tonal Contrast - The difference or range between the darkest point and the brightest point in the scene.

Tone - The darker shades of the tones (mix a color with varying amounts of black).

Top Light - Light originating from above.

Transmission - When light passes through without modification (through air or clean glass, etc.).

Triad - Composing with three colors that are equidistant from each other on the color wheel.

Tungsten - A man-made type of light commonly found in private residences; gives off a yellow-orange color; also a WB setting on the camera.

Twilight - Just after the sun has set, while the light from the sun still illuminates the sky; lasts until all color leaves the sky, usually 30-45 minutes.

Underexposure - An image that is too dark, not enough light entered into the camera to render a bright enough exposure.

UV Filter - A filter that removes the UV rays that you will not see but will degrade the quality of your image.

Value - The overall brightness or darkness of the color or tone.

Visual Weight - The visual pull of a compositional element.

Wavelength - A measurement of the different rate of fluctuations in the electromagnetic field that surrounds light photons.

White Balance - A camera setting to adjust for color changes in light.

Wide Angle Lens - Lenses denoted with a focal length of less than 35mm, which give you an angle of view of 60° of more, an elongated perspective, and a naturally deeper DOF.

Zoom Lenses - Lenses that can "zoom" or move through multiple focal lengths.

Zooming - A creative technique that uses a long shutter speed and movement of your zoom lens to create swirls of light.

Index

31634305R20077

Made in the USA
San Bernardino, CA
16 March 2016